THE ART OF CRAYON

THE ART OF CRAYON

DRAW, COLOR, RESIST, SCULPT, CARVE!

LORRAINE BELL

ROCKPORT

Quarto is the authority on a wide range of topics.

Quarto educates, entertains and enriches the lives o

our readers—enthusiasts and lovers of hands-on liv

www.QuartoKnows.com

First published in the United States of America in 2016 by

Rockport Publishers, an Imprint of

Quarto Publishing Group USA Inc.

100 Cummings Center

Suite 406-L

Beverly, Massachusetts 01915-6101

Telephone: (978) 282-9590

Fax: (978) 283-2742

QuartoKnows.com

Visit our blogs at QuartoKnows.com

10 9 8 7 6 5 4 3 2 1

ISBN: 978-1-63159-101-3

Digital edition published in 2016

eISBN: 978-1-62788-855-4

Library of Congress Cataloging-in-Publication Data available.

Design: Traffic Design Consultants

Front cover: Detail: *Untitled* by Jane Davies

Back cover: *Game of Thrones* by Hoang Tran

Inside cover: *Poppies* by Christian Faur

Page layout: Laia Albaladejo

Photography: All photography by Lorraine Bell, except where otherwise noted.
 All artist profile photography by the artist, unless otherwise noted.

Printed in China

DEDICATION

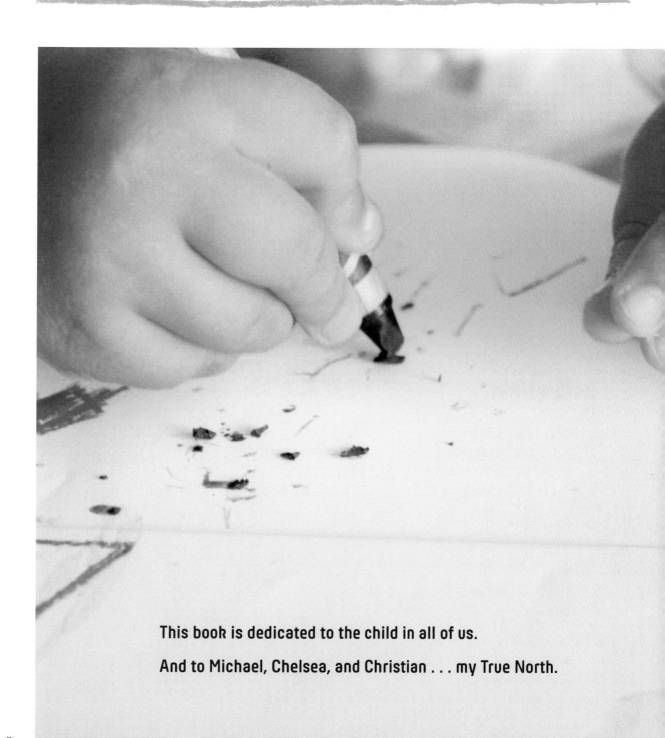

This book is dedicated to the child in all of us.

And to Michael, Chelsea, and Christian . . . my True North.

Photo credit:
Rae Missigman

CONTENTS

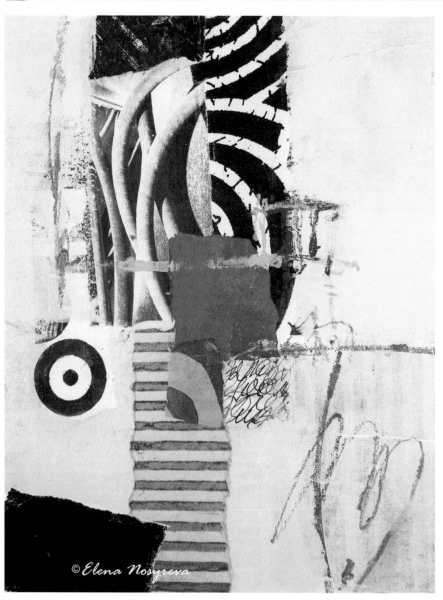

Target, collage with crayon, by Elena Nosyreva

INTRODUCTION

"Artists are just children who refuse to put down their crayons."
—Al Hirschfeld, artist, caricaturist, 1903–2003

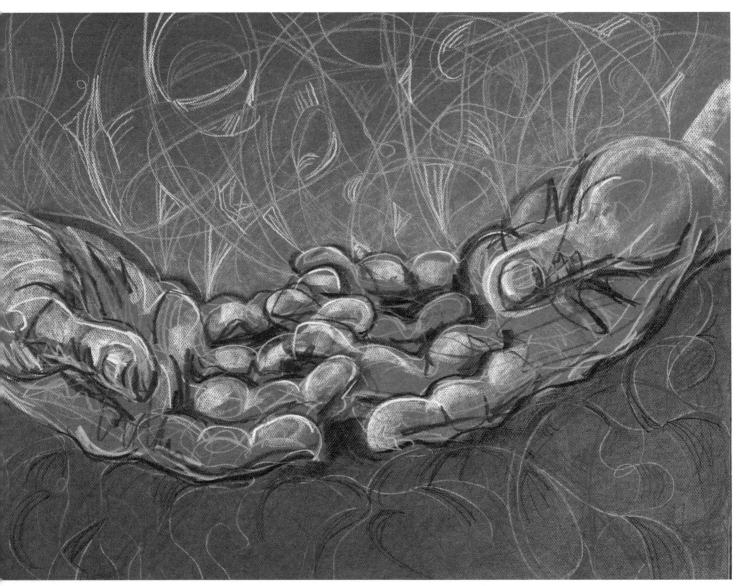

Connection by Fred Hatt

What is it about crayons that's so appealing? Why do they still whisper, "play with me," with a hint of waxy breath when we catch a glimpse of them in an open box? Perhaps it's the array of colors that causes receptors in our brains to fire. Maybe it's the memory of sprawling on the floor and drawing fearlessly for hours, without rules about color, line, or composition.

No one ever had to teach us how to hold a crayon or what to do with it. That may be part of the appeal—just grab it and get to work. Don't like what you've drawn? Throw it away, there's nothing precious about it. Crayons don't dry out. You don't have to set them up, replace cartridges, and clean up after them. You can use them sharp, dull, or on their sides, and they work just as well when they've broken to bits.

Artist-color specialists such as Caran d'Ache and Staedtler earned their reputations in part from the quality of their professional-grade crayons—also known as wax pastels—that have been favored by artists from Toulouse-Lautrec and Picasso to Cy Twombly and Henry Moore. As will be very evident on these pages, professional-grade crayons are still a favorite tool of artists and are used with brilliant results both as a solo medium and combined with pencil, ink, paint, and collage.

But, hold on to your Crayolas; that's only the start of today's story. A new spectrum of artists is going back to their roots, rediscovering the humble wax crayons of their youth, and using them to create incredible art in ways the manufacturers never dreamed of. Think of wall-sized portraiture, environmental constructions, assemblage sculpture, and microcarvings that take advantage of the humble crayon's amazing range of colors and waxy strength but have absolutely nothing to do with making marks on paper. "Play with me" has become more than a whisper these days.

In this book, you'll find an exciting array of works by contemporary artists using all varieties of crayon in ways that may astound you. In between are workshop projects based on the artists' techniques for you to try. By the time you finish exploring this exciting "new" medium, you'll never think of crayons in the same old way again.

Maneki, carved crayons, by Diem Chau, 2013

Crayons 101

"We are all born artists. If you have kids, you know what I mean. Almost everything kids do is art. They draw with crayons on the wall."
—Kim Young-ha, novelist, b. 1968

We all know what a crayon is, don't we? It seems like a simple enough question, but the line blurs with the number of crayon varieties and first-cousins of varieties available. The word *crayon* is ambiguous. Even in its most basic dictionary definition, it's described as a small coloring stick made up of pigment in a binder of wax, clay, chalk, or charcoal—that's four varieties already. Yet for most of us, and certainly for the focus of this book, it's the waxy sticks of various grades that we're focusing on when we talk about crayons.

When we think of our childhood crayons, it's the bright, beautiful colors that we remember along with the distinctive aroma of paraffin that follows them everywhere. In fact, in a Yale study on scent recognition, the smell of crayons was number eighteen in the top twenty recognizable smells of American adults.

But wait—scent no longer defines even children's crayons anymore. Manufacturers such as Prang and Dixon Ticonderoga now produce crayons with a soy binder instead of paraffin. Faber-Castell makes theirs with beeswax and not the slightest whiff of paraffin.

It might seem that the presence of wax and the surname "crayon" are what separates childhood's coloring sticks from their fine-art cousins, pastels. But the two words crop up interchangeably with variations in different places. Look up *pastel* in the dictionary and it's defined as a crayon. Firms such as Sargent Art offer Water Color Crayons, Reeves has Watersoluble Wax Pastels, and Caran d'Ache its Neocolor Wax Pastels, also known as color sticks or crayons.

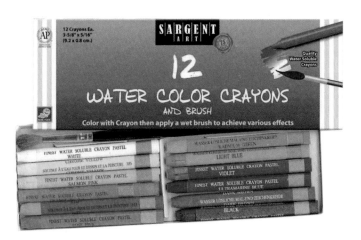

Sargent watercolor crayons

Marks made with an oil-wax crayon, left, and a child's wax crayon, center, resist water. A water-soluble wax crayon, right, can be used dry or as watercolor.

Actually what distinguishes children's crayons from artists' crayons is the high concentration of pigment in the latter, making their color denser and more light-fast and permanent. The quality of the wax is also more malleable than that in children's crayons, yet the wax gives artists' crayons a firmness for direct line drawing that pure oil pastels lack. On paper, artists' crayons have a saturated color, without a waxy shine, and they blend easily with a fingertip. Blending with children's wax crayons has to be done by layering color or by breaking down the wax with mineral spirits.

But there is yet another category of crayon that makes blending easy. Water-soluble wax crayons and pastels are available in all grades, from those made for three-year-olds to professional fine-art quality. They can be used dry, like an ordinary crayon, or used like a watercolor with water and a wet brush. The higher the density of the pigment in the crayon, the truer its color after a wash with a brush or when used on top of watercolor. Look for the words *water-soluble*, *aquarelle*, or *watercolor* on the packaging.

However you wish to define crayons—children's grade or professional grade, straight wax, oil wax, or water-soluble wax—all are welcome here in celebration of *The Art of Crayon*.

A Little Crayon History

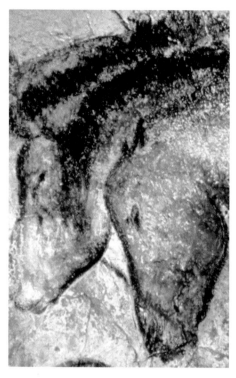

Upper Paleolithic cave painting of animals from the Lascaux Cave complex in Dordogne, France. The painting is estimated to be about 17,300 years old. Bridgeman Images.

You could say that the crayon's colorful history is as old as art itself. Paleolithic cave dwellers in Europe mixed earth and soot with animal fat to draw magnificent images on the walls of their caves.

By 2000 B.C.E., the Greeks had discovered that pigments blended with melted beeswax made an effective paint for decorating and waterproofing their ships. In the first and second centuries A.D., the use of beeswax and pigment would be refined in Egypt's famed Fayum mummy portraits (see *Portrait of a Woman* on page 13). They're the earliest colored-wax images known to survive.

Of course, none of these examples used actual crayons, but they do demonstrate that enterprising craftsmen discovered very early on that pigment mixed with grease or wax made an effective, long-lasting colorant. Those Paleolithic drawings are still preserved on cave walls.

The Perfect Recipe

The history of the crayon, as we know it, begins a bit later. The first known reference is from Leonardo da Vinci, who mentions using wax crayons for drafting in his notebooks, which date from 1492 to 1515. What they looked like and whether he made them himself, no one knows.

Like chefs developing gastronomic delights, European artists in the sixteenth and seventeenth centuries continued to seek recipes for enhancing their drawing experience. The few records known to exist do include recipes for drawing materials made by mixing pigment with binders such as beef fat, fish oil, gum Arabic, whale oil, and olive oil.

Nineteenth-century records expressed frustration with the wax-based drawing sticks that were available at the time. These early drawing sticks, which were still in the experimental development stages, made marks that stayed put on the page without flaking or smearing, but they offered little in the way of drawing subtlety. In 1835, the newly formed German pencil-manufacturing company J. S. Staedtler developed a colored-wax crayon encased in wood that, despite the extreme hardness of the beeswax, was widely accepted by artists.

Staedtler's crayon marked the beginning of the search for the perfect wax crayon—not too hard, not too soft, and with rich, long lasting pigment. Over the next century, hundreds of versions would be made.

The Modern Crayon

In the late 1800s, the firm of Offenheim & Ziffer in what would later become the Czech Republic produced a multihued range of crayons, replacing expensive beeswax with a wax called ceresin. Ceresin was derived from bitumen coal, making it the true forerunner of the petroleum- and coal-derived paraffin that we associate with crayons today. In 1882, the New York Academy of Sciences praised this breakthrough: "The writings and drawings made with [ceresin] crayons can be effaced neither by water, by acids, nor by rubbing."

With the end of the American Civil War, U.S. manufacturers joined their European counterparts. E. Steiger & Co. and Franklin Manufacturing Co. in New York were two of the frontrunners. Charles A. Bowley from Danvers, Massachusetts, is credited with being the inventor of the modern paraffin-wax stick. Bowley formed his crayons into cylinder shapes similar to that of a pencil and sold them in decorative boxes. Eventually Bowley merged his business with the Ohio-based American Crayon Company.

The advent of American crayon manufacturing happened to coincide with the establishment of the kindergarten movement and an interest in children's education that was sweeping the country. It followed that the Prang Educational Company, Milton Bradley, Joseph Dixon Crucible Company, Eagle Pencil Company, American Lead Pencil Company, and Standard Crayon Company were soon producing crayons for schoolchildren.

Enter Crayola

Edwin Binney and C. Harold Smith, producers of slate pencils and dustless chalk were among the manufacturers who recognized the need for safe and affordable school supplies. In 1903, their new product was a wax crayon that became known as Crayola. Edwin Binney's wife, Alice, a teacher herself, came up with the name from the combination of craie, which is French for "chalk," and ola, short for oleaginous or "oily." Binney & Smith debuted their box of eight original colors in pristine wrappers for a nickel. They've been in the hands of children ever since.

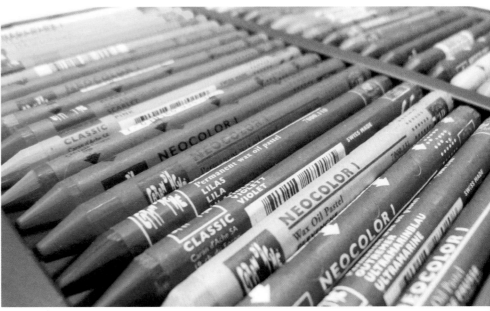

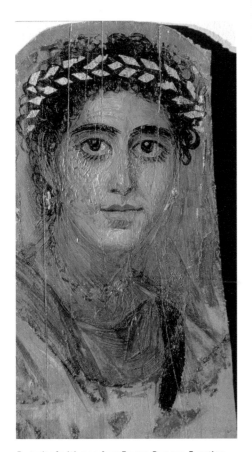

Portrait of a Woman, from Fayum, Romano-Egyptian, A.D. 131–161. Encaustic wax and paint on wood. Metropolitan Museum of Art, New York. Bridgeman Images.

Crayons for All

Crayons might have moved from the atelier to the kindergarten classroom, but fine artists never released their hold on them. The use of oil and wax pastels by artists paralleled the development of crayons produced specifically for children. Then, in the early 1950s, the Swiss firm of Caran d'Ache, came out with a drawing tool that combined the two interests: Neocolor I crayons. These highly pigmented wax crayons became popular with both amateurs and professionals and, from the start, were sold in toy stores and artists' supply shops.

"Europeans had the same experience with the primal smell and flood of childhood memories as Americans did with their most popular brand," says Caran d'Ache's Stefan Lohrer. In 1972, the company launched its water-soluble Neocolor II crayons, which have been a first choice for artists ever since.

The variety and versatility of crayons has grown, merged, diverged, and developed for artists of all ages and work on all surfaces, in a wide range of quality and cost, but always colorfully. The long and colorful history of crayons shows no sign of stopping.

ED WELTER
CRAYON AFICIONADO

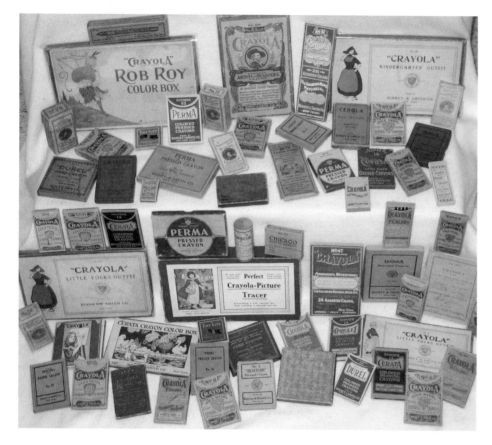

When it comes to mapping out the history of crayons, all fingers point to Ed Welter, collector and archivist. Welter's love of crayon collecting began by accident when he won an item on an online auction that came with a bonus gift of a vintage box of crayons.

Welter, a former project manager for Nike, was immediately captivated and began a hunt to find out as much as he could about the mysterious box. His curiosity led him to discover that crayons had an untold story. According to Welter, "Crayons anchored everybody's childhood, but there was no history written about them at all."

Prior to Welter's research, no one had put together a timeline of the crayon's journey. Now, after fourteen years of collecting, Welter is hailed as a pioneer of crayon history by collectors and manufacturers. He managed to amass more than 3,000 boxes of crayons—some of which date to the 1880s. Imagine the waxy scent of the 80,000-plus crayons filling every square inch of wall space in Welter's collection room.

At first, Welter searched for crayon memorabilia mainly on eBay but soon realized that the inventory available was limited. With the mind of a treasure hunter, he began to use his investigative skills to track down potential crayon sources.

"If I were a crayon," he asked himself, "where would I be?" He began talking with art teachers and crayon suppliers who inevitably led him to stashes of vintage sets. When Google began digitizing old periodicals, he found more information and his historical timeline began to take shape.

Welter's first great windfall came when he began reaching out to people living in and around Easton, Pennsylvania, where Crayola headquarters has been since 1900. He

contacted a family with a farm adjacent to Crayola's plant and was happily surprised to learn that through the decades, the family had provided business visitors to Crayola with a place to stay. In lieu of payment, the family asked their guests to bring them a box of crayons, and in time they had a collection of more than forty now-vintage sets, which Welter was able to purchase.

With very little written information available and only a handful of other crayon collectors to confer with, Welter took on the daunting task of documenting everything he learned about these little wax sticks. His research became so complex that he started a website, where he chronicled a comprehensive list of everything he found.

The more collecting Welter did, the more he realized crayon history was a piece of Americana worth preserving, and his role morphed from collector to historian and aficionado.

Others soon recognized his expertise and began to approach Welter for historical facts, crayon values, and ages of crayons. If you ever wondered who developed the flip-top crayon box or you needed a list of every known crayon manufacturer, Welter was the person with the answers.

Through his research, Welter became an authority on crayon color, compiling the most comprehensive list of crayon colors in existence. He notes that, with a few exceptions, most crayon colors are not arbitrary, but come from the Federal Standard: a color guide used by all U.S. government and military agencies.

By the time Welter completed his research, he had identified and logged 1,629 different crayon colors. His knowledge of crayon color has had its own attraction for researchers.

Ed Welter and family in the collection room

These have included a professor from Northumbria University in England, who was trying to identify the crayons used in works by renowned Norwegian artist, Edvard Munch, in the early 1880s.

The coauthor of Wikipedia's article on crayon history, Welter would be the first to agree that pinning down the historical data of crayons has been ridiculously complicated, though that's what he's loved about it. Still, he admits, even with all his painstaking investigations, there were crayon mysteries he was never able to solve before selling his massive collection in 2014 and retiring with his family to Spain.

Welter's website crayoncollecting.com, jam-packed with his research, remains available to anyone interested in the colorful past of crayons.

DRAWING

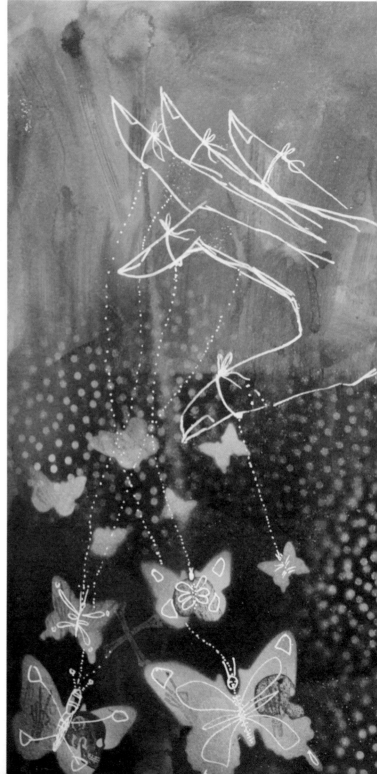

Jane Davenport blends crayon with acrylic paint
to create flesh tones and to define eyes.

Introduction to Drawing

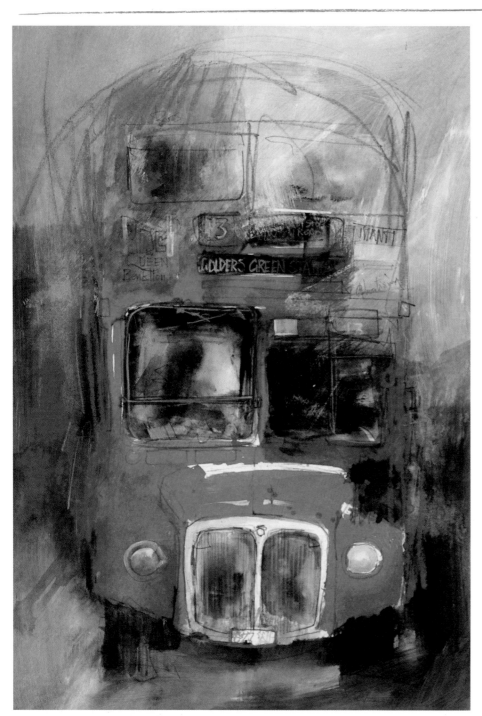

Last Bus Leaving. John Lovett used red crayon to finish lines that were not painted in.

A CRAYON DRAWS ANY WAY YOU WANT

Why choose crayon for drawing? The more apt question may be, why not? First of all, there's the boldness of color. A swift gesture on a blank page with a black crayon and the page comes alive. You've got something to look at—and you don't have to come in close to see it.

Then again, if you'd rather, you can let the point of the crayon whisper across the page when you draw. Feather it lightly for the subtlest of outlines while your drawing decides where it wants to go or you decide where you want to take it. What comes next is up to you.

Choose another color and draw on top of the outline you've already created. Depending on the colors you choose and how you decide to layer them, you might see through to the first color, or cover it up completely. Now turn the crayon on its side and shade with it, creating shadow and dimension and mood, filling in wide swaths with a single sweep of color.

Crosshatch with layers of different crayon colors so that they blend in interesting ways—you'll watch completely new colors and shadings evolve. That's another fine thing about crayons—all those colors. Maybe the black one, or the charcoal gray, will be your trusty go-to drawing tool, but all the other colors are waiting there, too, ready to go to work when you decide a green shadow is exactly what you want in a portrait, or a lipstick-red line is just what a drawing needs to make it pop. The crayon's waxiness lets you add it subtly or boldly.

And, yes, that waxiness—there's that aspect to drawing with crayons, too. Wax doesn't just lie down, it sticks, allowing you to draw on top of everything. Draw on top of a pencil line, and the waxy wake of the crayon will pull the graphite along, giving it a slick, wet look and a fluid maneuverability. Draw heavily with crayon and you've got the boldest color achievable on paper, with a waxy gloss that no other drawing material produces. Then, if you want, go back to that waxy gloss and draw into it again with a stylus for a sgraffito effect. A pencil won't let you do that.

Finally, let's not forget what is perhaps the most important thing about drawing with crayons. We've all held crayons since we were two years old. There is simply no other drawing tool that feels so at home, so uninhibiting, so natural to draw with as the one we knew first.

Prophet. Artist Fred Hatt builds a portrait with layers of colored line and then allows the viewer to decipher the stories behind the model's eyes.

ALETHA KUSCHAN
IMPOSSIBLE LIMITS

MUSEUM PLAYGROUND

Growing up in Washington D.C., Aletha Kuschan was fortunate to have had the National Gallery of Art as her playground. As a young child, she frequently accompanied her mother on trips to the galleries to look at exhibitions of old and modern masters. One painting in particular had an enormous impact on her life and on her art. *Mary, Queen of Heaven* by The Master of the St. Lucy Legend influences her art, even today.

Kuschan speaks of the extraordinary, intense colors of the painting and says she has only found that same intensity when she works with crayon—Caran d'Ache Neocolor II crayons, to be exact.

Even now, however, Kuschan picks up a child's crayon when she starts a study: the same kind of crayon she first used as a child. Crayons are economical and portable, she notes, and if she can create something beautiful from a child's art material, it stands to reason she can bring it to a professional level using finer art supplies.

"Sometimes the expense of quality art materials can add an intimidation factor to the creative process," she explains. By using a crayon, Kuschan allows herself the freedom to "just mess around." It helps her fool herself into taking risks and pushing the crayon to seemingly impossible limits.

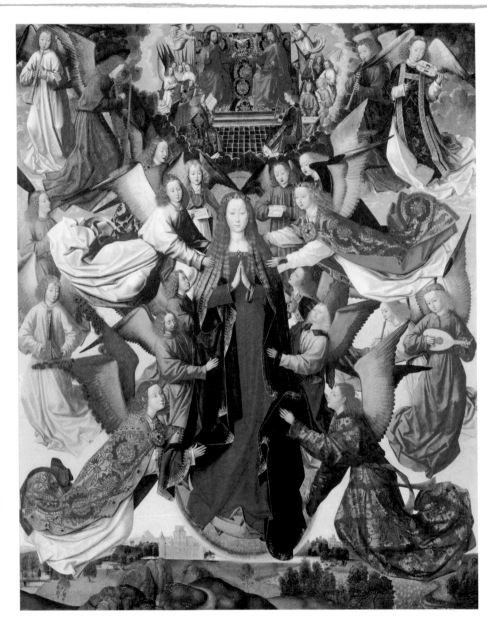

Mary, *Queen of Heaven*, c. 1485–1500, by the Master of the St. Lucy Legend. Oil on panel. National Gallery of Art, Washington, D.C. Bridgeman Images.

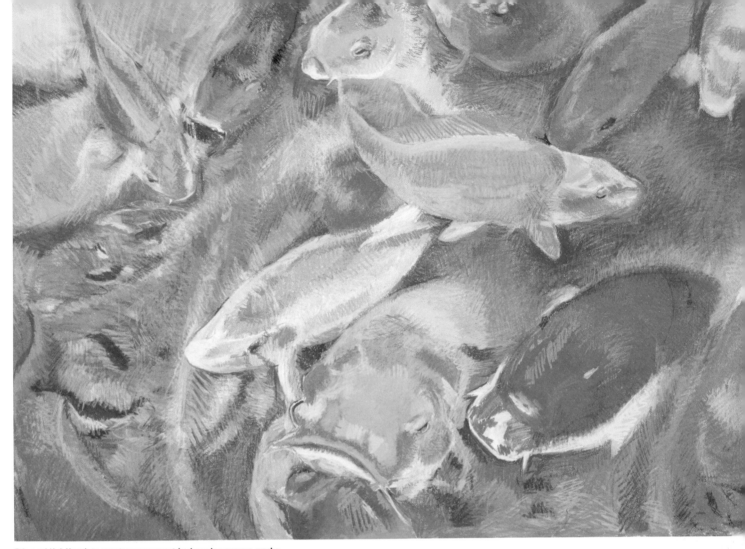

Ethereal Koi. Kuschan creates movement by layering crayon marks.

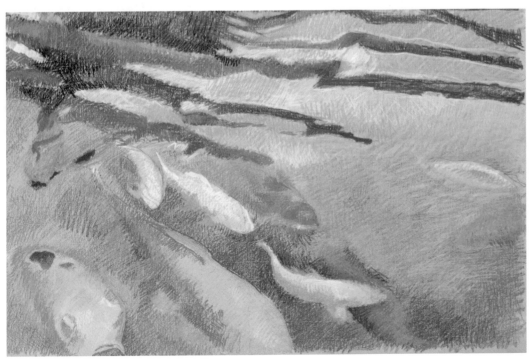

Dynamic Swimmers. Deepest blue shades show depth and white crayon marks are used for highlights.

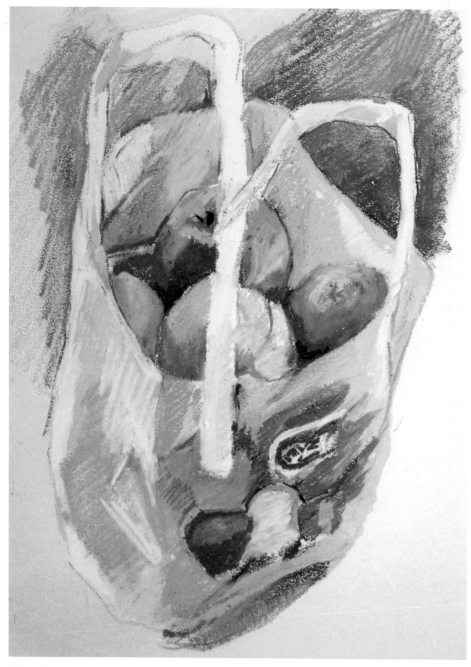

A Bag of Apples. Crayon on Strathmore 400 series watercolor paper.

Paper Is Part of the Medium

Kuschan is known for her crayon "paintings" of koi—large, vibrant images of bright blue pools crowded with fish. Her crayon lines are like painted brushstrokes and the addition of water to the marks creates a veil of color and intensity of pigment.

Initially she viewed these large works as rehearsal drawings, but then realized they are the finished works. Drawing on a scale that requires her to extend her arm entirely is exhilarating, and she believes it's made her a better artist.

Substrate is as important to Kuschan as the art medium she uses. In fact, she says the paper is a part of the medium. Paper plays an enormous role in how the crayon appears. It behaves differently on rough-textured watercolor paper than it does on a brown paper bag, although she uses both in her work. "It's not just how the crayon moves across the paper," Kuschan explains, "but also how the viewer sees the crayon on various substrates." Kuschan prefers Canson Mi-Teintes papers because of their durability and color range. She frequently creates her drawings on toned paper to achieve unusual effects in the color mixes.

Kuschan draws freely in the initial stages of her work, putting lines where she thinks they might belong, knowing she can correct them later. From there, she says, "I've found that artists' crayons can produce a kind of drawing–painting very similar to the effect Degas achieved through the use of traditional dry pastel."

Continuing her childhood fascination with art, Kuschan spends time in museums, making studies by copying masterworks. She keeps her crayons handy for these excursions.

She's discovered that she can duplicate most color effects almost exactly by using crosshatching and blending techniques with crayon—the perfect, portable medium.

Shimmering Surfaces. Striking crayon marks in cool and warm colors add depth to the piece.

Recollected Ocean. Kuschan uses vibrant crayons in her conch shell series.

Study of a Koi. An excellent demonstration of crayon crosshatching.

FRED HATT
CRAYONS IN MOTION

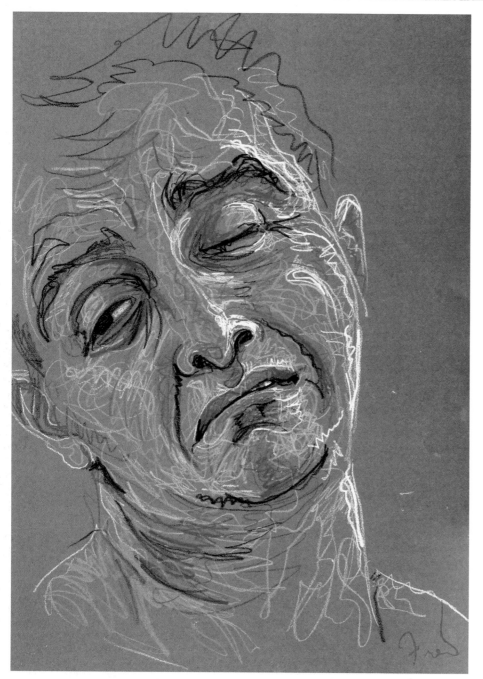

Cracked. Nontraditional skin tones work well with this model's expression.

DYNAMIC FORCES

Fred Hatt's crayons dance across the page as he creates portraits that look as though his art box has exploded. He talks about being inspired "by a vision of the world as a living manifestation of dynamic forces rather than as a collection of separate objects and beings." What better place to find stimulation than fast-paced New York City where he resides and works.

"I'm interested in art more as a process than as a product," Hatt explains. Working with live models, he's discovered drawing as movement and energy. "A model's pose," he says, "feels like a gift of human presence that I want to honor by doing as much as I can to portray the model's character and life force." Hatt considers his models cocreators in his work and embraces the give-and-take of subject and artist.

Speed is essential for Hatt in capturing the living, breathing person in front of him. He works with Caran d'Ache Neocolor II crayons because they allow him to sketch quickly without smearing or blending. His marks are deliberate, each one recording a perception or expression. He uses the vibrancy of the crayon pigment to make his portraits jump to life as if they are electrified.

Selecting a gray or mid-toned paper for his compositions, Hatt begins a drawing by defining the contour of his image. Then he works faster as value is established and skin tones emerge with depth and translucency. He finishes each piece by dashing in color to develop the personality of the subject.

Clear Sight.
Minimal crayon
marks depict
contour.

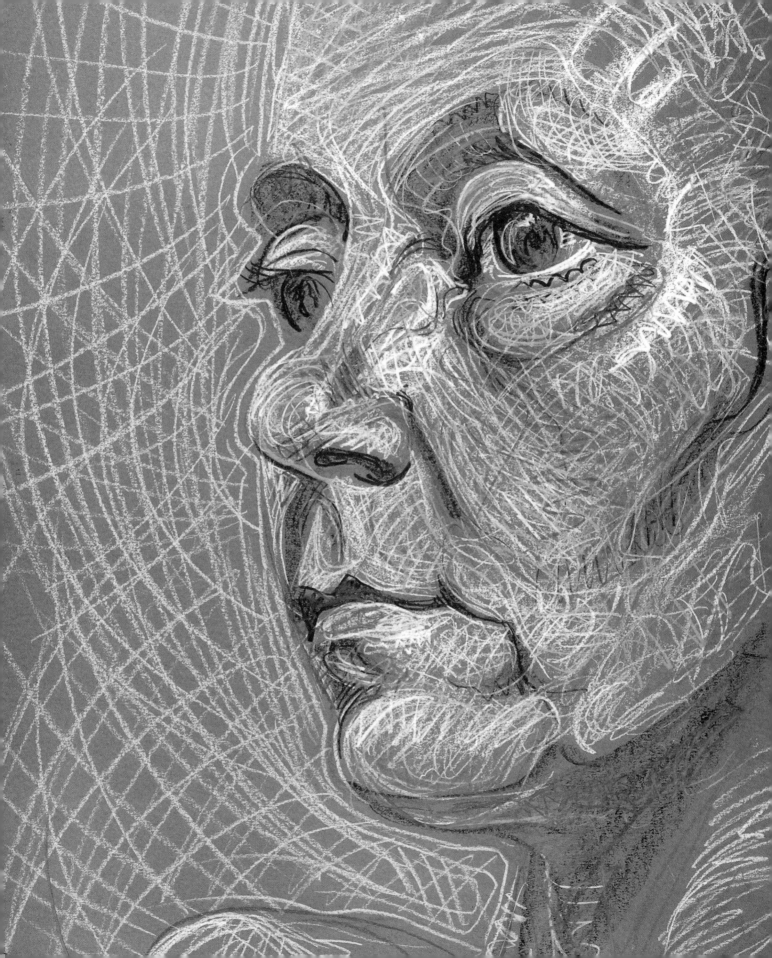

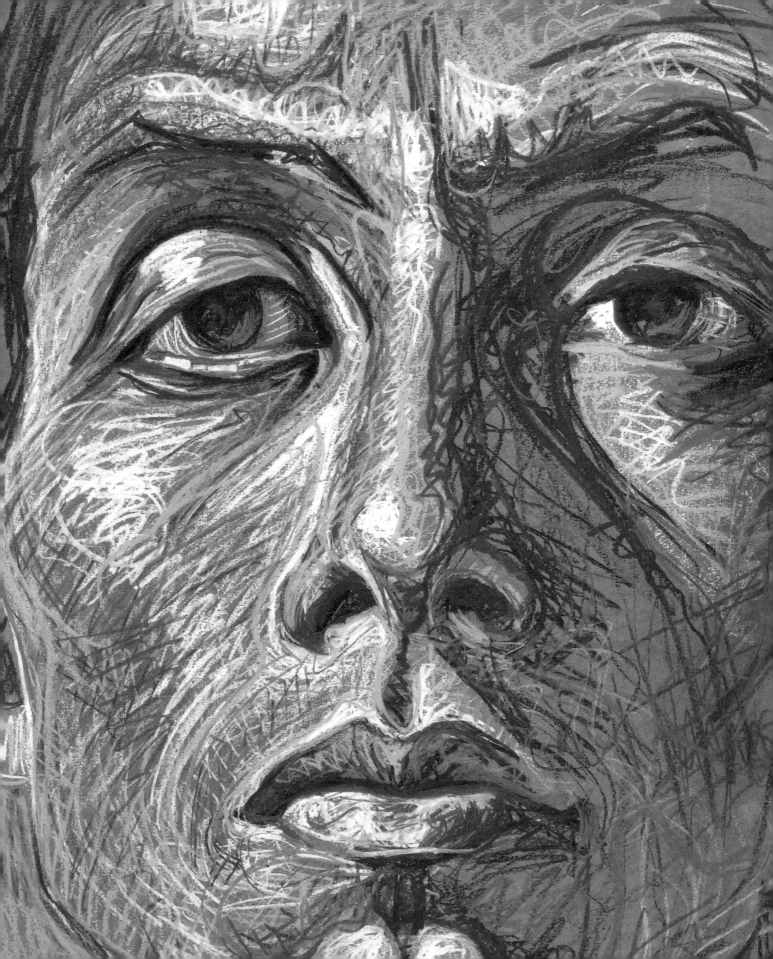

Optical Mixing

Hatt alternates between precision and looseness deliberately in his drawing to achieve his desired effect. The dichotomy allows his marks to be perceived as being separate while at the same time merging. He developed a technique of optical color mixing whereby colors are placed close to each other but are not actually blended on the page, so that the viewer's eye makes the combination. The picture is completed in the viewer's mind. Crayon is the perfect medium for this technique as each mark maintains integrity as he builds up the drawing.

Hatt proclaims himself an outsider in the art world, never allowing himself to be influenced by marketing demands or buying into the "contemporary discourse of theory and criticism." Having said that, he has an international following on his blog and other sites. Art teachers and students study his work, and he has been featured in American Artist's *Drawing* magazine. Hatt creates for the sake of fulfilling his own desire to have a deep, personal connection with the dynamic forces around him. His work is not only art, it is a performance.

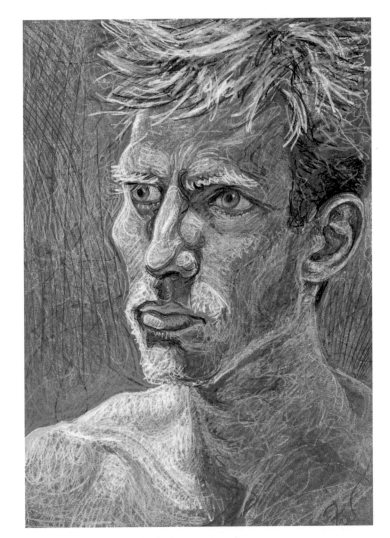

Andrew. Hatt's use of line and color demonstrates value.

Esteban. The contrast of light and dark values shows the intensity of this model's features.

Connection. A crayon on its side adds highlights and height.

PROJECT:
Crayon Portrait on Textured Paper

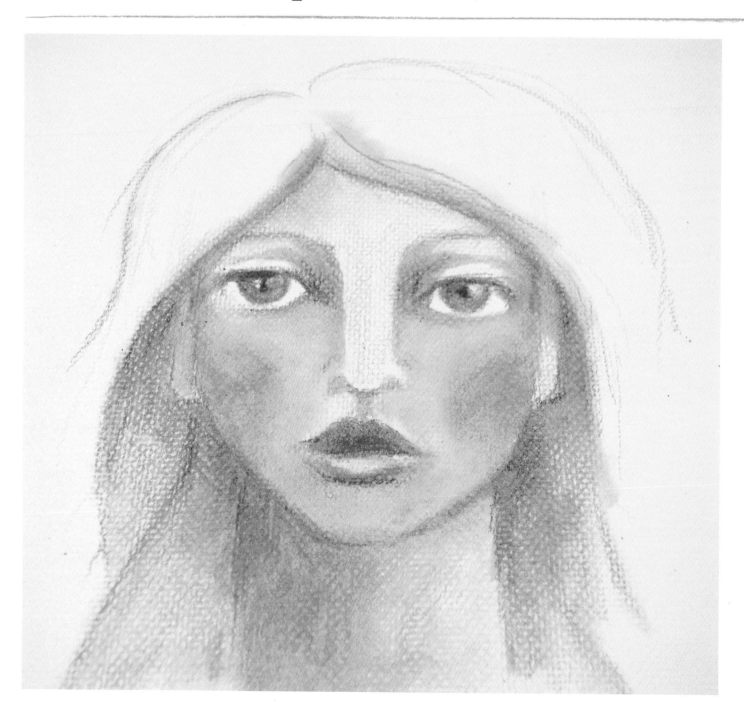

SPIRITED DRAWING: HOW TO GET THE MOST OUT OF AN ORDINARY WAX CRAYON

Once I'd determined that crayons are not just for kids, I wanted to find out just how well they hold up as a drawing material. I decided to experiment with one of the subjects I often tackle in my art classes and journals—the whimsical portrait.

You can apply these steps to any type of drawing where shading and blending of colors is needed. Children's crayons do have their limits in terms of waxiness and pigment quality, but there are definitely techniques you can use to make them behave in a professional way.

Choose Your Colors

As with any drawing project, you have choices with crayon. You might want to stick with a very limited palette of neutrals, for instance, to experiment with the range of tones you're able to achieve. Or perhaps you'll go with primary red, yellow, and blue to test color blending at its most basic level. I went the opposite route and chose a sixty-four pack of Crayolas because I wanted to play with a wide range of colors and tones from light to dark.

Blending Colors

As you may remember from grade school, kids' wax crayons do not blend together when you try to smudge them with a fingertip. Crayon color pretty much stays exactly where you put it.

But that "stay put" quality of wax crayon allows to you blend it in other ways. No matter how lightly you bear down on a crayon when you draw, it leaves a trace of itself behind. Shade an area with the faintest touch of crayon. Then go over the shaded area with a faint hint of another color. Perhaps add a third, and then back to the first. Add more layers of near-transparent color in one area—fewer layers in another—over and over again until you achieve the effect and the contrasts you're after. Wax crayon allows you to blend and develop tonality without having the color smudge into areas where it doesn't belong. It blends up, it doesn't move left or right.

Blurring the Lines

What if you want the color to move left and right, or you want parts of a drawing to have a soft, watercolor effect? That is possible, too, because the wax in crayon breaks down with an application of mineral spirits or turpenoid. Make sure you have proper ventilation when using mineral spirits.

For broad washes of color, you can dip a soft cloth into the mineral spirits and rub it over the colored area to blend it as you like. For areas where there is a heavy, waxy buildup of crayon color, try dripping small amounts of mineral spirits on the wax to see how it breaks up and exposes the layers of color underneath.

For a detailed drawing, your best choice is to work the mineral spirits with a blending stump—also called a tortillion. This handy little tool, found at any art supply store, is made of rolled paper and is shaped somewhat like a crayon. When dipped in mineral spirits, it will hold just enough to apply to a drawing without dripping. The pointed end of the stump allows you to carry the blending into the smallest areas of a drawing, exactly as you want it.

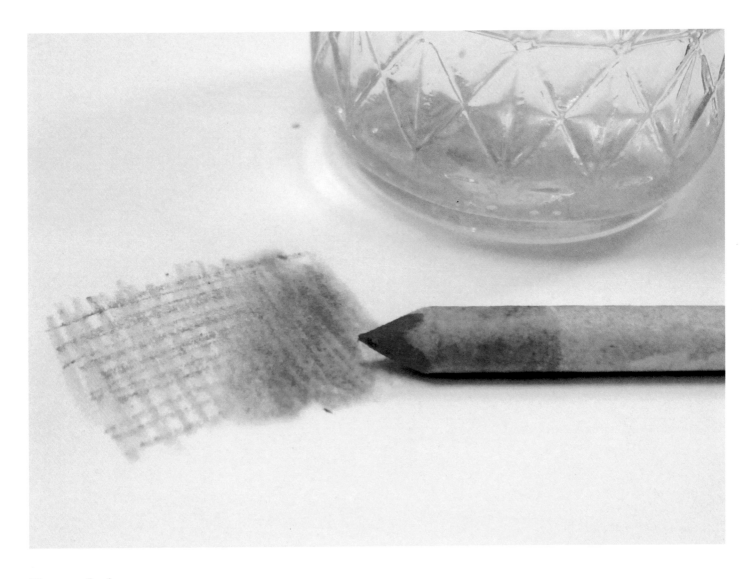

Choose a Surface

I chose 140 lb (300 g/m²) cold pressed, slightly textured, watercolor paper for my drawing. It has a smooth surface, is good for portraiture, and has a weight that holds up to the moisture of mineral spirits. The texture is an added bonus when crayon is applied. For an abstract drawing, experiment with crayon and mineral spirits on smooth Bristol paper. For a translucent, stained-glass effect, try the materials on artists' vellum. With so many choices, I'd almost forgotten these were children's crayons I was working with.

I colored my portrait using crosshatching strokes in layers of different hues to develop the skin tones. For the most part, it worked well. By blending the wax with a mild solvent, I was able to achieve an effect that I was happy with.

Tools and Materials

- 140 lb (300 g/m²) cold pressed watercolor paper

- wax crayons

- odorless mineral spirits or turpenoid

- small glass jar

- blending stump

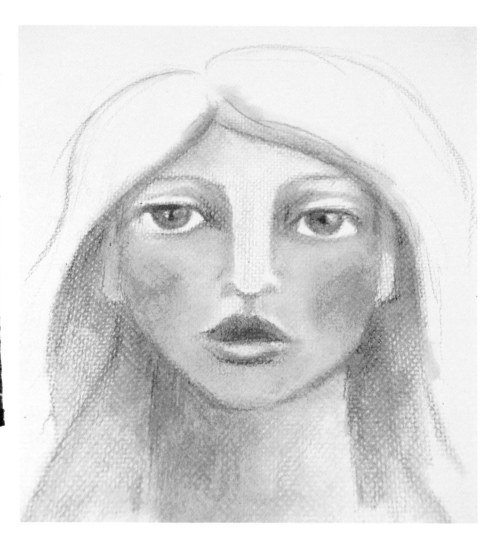

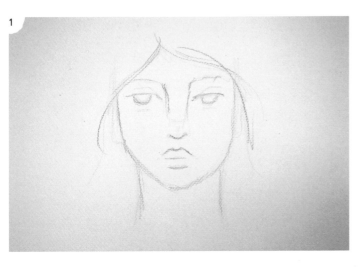

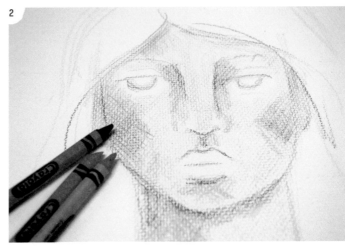

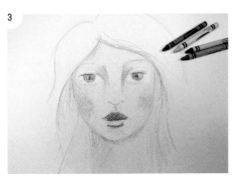

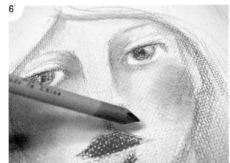

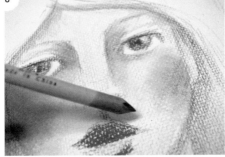

5. Pour a small amount of mineral spirits into a glass jar. Dip the tip of the blending stump into the mineral spirits. Working in one small area at a time, run the stump over the crayon drawing, smoothing and blending the color.

6. Go back and forth between the drawing and the mineral spirits until you are satisfied. Leave some areas unblended if you like—you can always go back and blend more areas later if you want to change the look. The mineral spirits will evaporate from the paper quickly.

7. When the drawing has dried, add line or color details by drawing over the blended areas with crayon, pencil, or pastels.

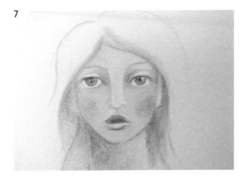

1. Place the paper on your work surface. Choose a crayon and begin by making a rough outline of the face shape.

2. Use deep colors to add shadows around the hollows of the eyes, below the chin, along the hairline and in areas that you want to appear recessed in the face.

3. Begin adding the skin, eye, and lip tones. I used a crosshatch technique, drawing a series of close lines in one direction and, working across the same lines, drawing in the other direction. With each layer of crosshatching, I alternated colors to add depth to the tone. Continue adding colors to the face over and over again to build up the facial features.

4. Use a variety of colors to add highlights and shadows. Depending on the effect you are after, you might alternate colors of similar value in natural hues, or add more dramatic contrasts with greens and blues in the skin tones.

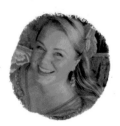

JANE DAVENPORT
FACING FANCY

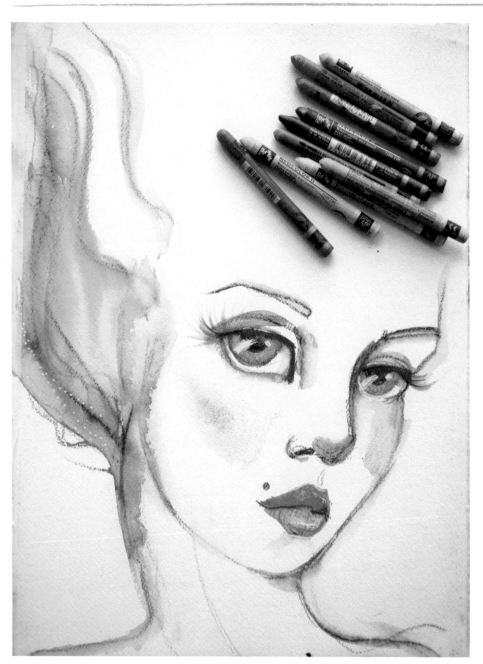

Neocolor soluble crayons create dreamy effects.

JOURNALING IN COLOR

"I am an artomologist," Jane Davenport announces, happily defining herself as the only one of her kind in the world. And it's true because her artwork is as unique as her self-proclaimed title.

Jane "Danger" Davenport's style combines high fashion and whimsical imagination, often in the form of dreamy faces of impish fairy folk and fierce glamour girls. She achieves her colorful, wide-eyed images through a process of mixing acrylic paint with crayon on the pages of the journals she creates with cold-pressed watercolor paper.

Davenport leans toward using water-soluble Neocolor II crayons. You can hear the excitement in her voice when she talks about the vibrancy of juxtaposed pigments before and after they're smudged, blended, and transformed. In her drawings, the background color often merges with the subject, heightening the ethereal playfulness and not-quite-of-this-world-ness of the characters she creates.

When she was growing up, Davenport says, she was fortunate to have a family that supported her art endeavors. She has vivid memories of her parents supplying her with a fine-art colored pencil set with its own special sharpener and case. She recognized even then that these were not the ordinary pencils that the other kids had. So, from a very young age, she learned to appreciate the quality of color. And she learned that art materials are treasured tools that add to your sense of pride in the work you create.

A Davenport fairy loosely drawn with crayon on a painted background

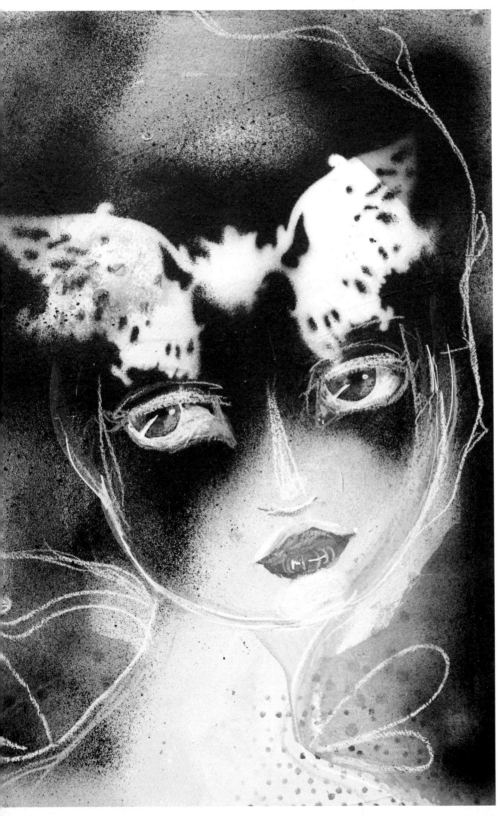

Defining Interests

The best-selling author of *Beautiful Faces* (Quarry Books, 2015), and a tireless teacher of her online Art Schools and Escape Artist retreats, Davenport's passion is in teaching and showing others how to "defy their creative gravity," she says. "If you are willing to take risks, others will see it and feel it." She runs her successful art business from her "nest" in Byron Bay, Australia.

As with many artists, Davenport circled through a range of interests before finding "the one." She got her start in fashion, and was working as a fashion photographer in Europe when she mounted her gallery series *The Ladybird Chronicles*, a series of sixty-four enormous photographs of insects, which toured three continents.

White crayon marks are striking on a dark background.

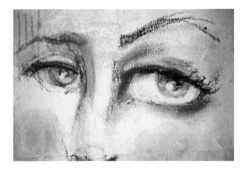

A close-up shows Davenport's use of crayons in creating her expressive eyes.

Entomologist to Artomolgist

While still focusing on her photography, Davenport moved through her fashion career as an illustrator, textile designer, and stylist. But it was in illustration that she found her niche. She began to teach art classes both online and in person and soon recognized this was her calling.

When she sits down to draw or work on her journals, Davenport typically does not begin with an inspiration. Instead she chooses to let her impish and fashionable faces emerge from her crayon and watches as they develop. Sometimes the faces seem melancholy when they first appear, she says, but once she adds color, they transform.

Davenport describes using crayon as a way to take creative risks without investing too much money or time in a project. "Crayons make me feel playful," she explains. "They take the pressure out of creating art."

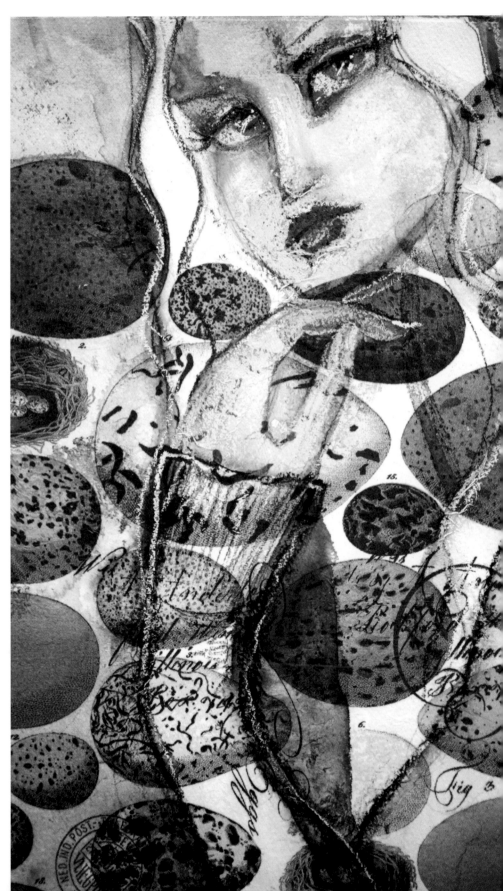

A Davenport fantasy figure painted and colored on printed paper

JOHN LOVETT
AUTHOR, PAINTER, AND TEACHER

ENGAGING MEDIUMS

John Lovett's works are hard to define: structured but ethereal, light-filled but moody, realistic but abstract—and absolutely gorgeous. From his home in Queensland, Australia, he works in oils, acrylics, and watercolor, but his preference is watercolor combined with drawing.

Lovett's use of crayon in his watercolor work began in his studio one day as he contemplated the repetitiveness of the watercolor in front of him. Having painted the same way for many years, the medium didn't excite him anymore. He didn't know where to go with it.

He picked up a couple of crayons that his children had scattered and began scribbling on his work "like a naughty child," he says. The result was exhilarating.

"For me," he says, "the unpredictability and uncontrollable nature of the combination of materials make it the most exciting and expressive medium of all. The opportunity to meander somewhere between mastery and complete lack of control during the course of a painting makes it completely engaging."

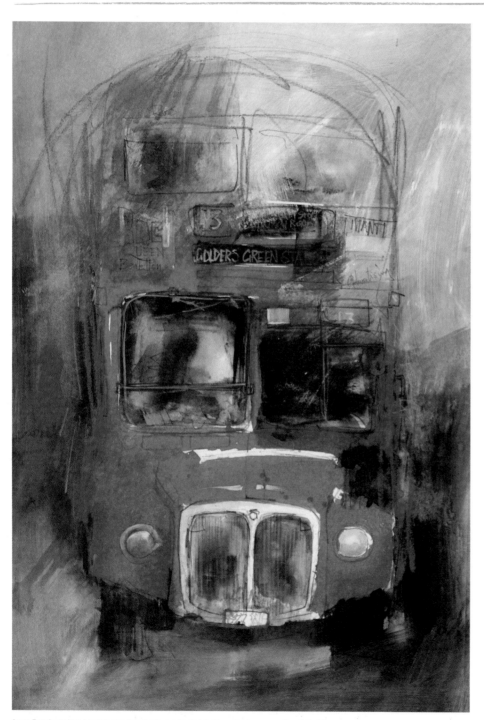

Last Bus Leaving. Lovett used red crayon to finish lines that were not painted in.
Photo credit: Dianne Lovett.

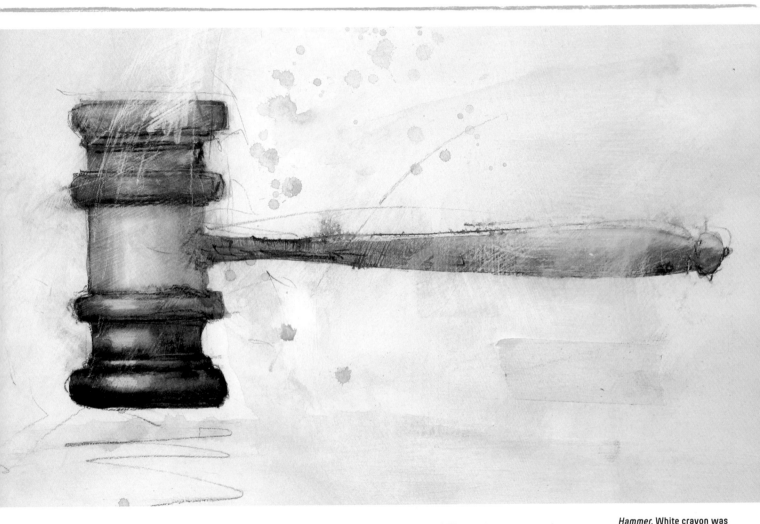

Hammer. White crayon was scribbled loosely over the hammer, showing movement and force.

Barramundi. Lovett used Japanese watercolors infused with bits of ground iridescent seashells. The scratchy crayon lines add movement to the piece.

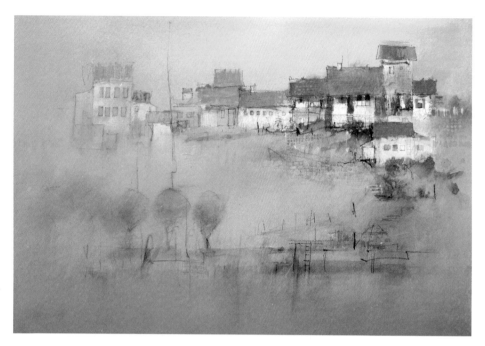

Build it Up, Take it Down

In his work, Lovett favors the juxtaposition of highly detailed work and slightly unfinished areas, merely making a suggestion to the viewer and allowing them to fill in the rest of the story.

Although he typically starts with a simple and economical under drawing, Lovett does not follow a sequential order in his work. He chooses instead to move between creating and destroying, building up areas, then taking them down again until the desired effect is achieved. The process is impulsive for him, and it evolves as he works.

Inlet. The use of striking vibrant pink crayon on the rooftops is one of Lovett's signature styles.

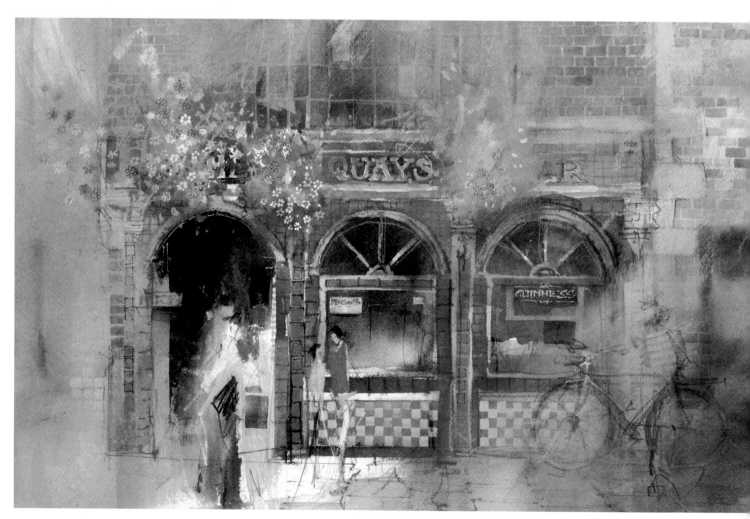

He uses gesso over areas in his paintings, diluting and feathering the edges until they disappear and a hazy, milky look emerges. Then he adds lines and images in the hazy areas with crayon and pencil—not quite details, but suggestions.

Lovett loves the fact that using crayon is not a commitment. Using Neocolor II watercolor crayons for his work, he can remove the color or blend and smear it until he has achieved the desired effect. The most important thing about using crayon with watercolor, he notes, is that it adds an edgy quality but always remains playful.

Lovett studied at the National Art School in Newcastle, Australia, where his classroom was wherever the instructor felt compelled to inspire his students, including the local pub. After graduating, he married and worked in a job that he says, "annoyed me enough to make me realize what it was I really wanted to do." His wife, Dianne, an art teacher, supported the family as he established himself as a painter. To date, he has had more than thirty-five solo exhibitions around the world.

Through the Streets of London. Lovett created this work on watercolor paper, leaving part of the underdrawing for interest. He used red crayon in a resist technique.

Monterey Reflections. Strong marks made with crayon appear in windows. White crayon adds bold interest.

The Quays-Dublin. Bright pink and green crayon make the image pop.

THE IMPORTANCE OF PROCESS

When asked, "Why crayons?" Herb Williams states emphatically, "Crayons are a gateway drug." The metaphor sums up the reality of Williams's relationship to the medium he uses most in his art—the Crayola crayon. Williams is one of the only private individuals in the world with a Crayola account. He buys a lot: whole cases at a time, each weighing 50 pounds (23 kg) and containing 3,000 of a single color. But the amazing thing about all of these crayons is that Williams doesn't use them to color—at least not in the traditional sense. He builds massive structures using the actual crayon stick or pieces that are meticulously cut and trimmed to form his incredible installations.

From his start in Montgomery, Alabama, Williams's route to sculpture began with building. Having lost his father at a young age, he began working in construction during school breaks. He became skilled as a carpenter, and grew to love and understand structure and form. Within a few years, Williams was dabbling in art outdoors, carving faces into Alabama's red clay. It never bothered him that his carvings dissolved with the weather. For him, the process of making the art was just as important as the finished piece.

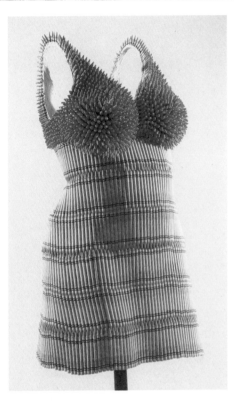

Herb Williams's play on couture is pictured in this unique piece entitled *Pink Slip*.

Williams went on to receive his B.F.A. in sculpture from Birmingham-Southern College in Alabama, where he also apprenticed for several professional sculptors. He was surrounded by talented, visionary people, and he paid attention. After graduating, he worked in a bronze foundry and further honed his skills by casting hundreds of sculptures for the atelier Popliteo.

Entry Call. Part of the Call of the Wild exhibit, an arc of crayons connects Williams's wolves. Photo credit: Ashton Thornhill.

LYNNE HOPPE
TINY TREASURES

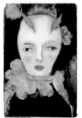

Patrice. Buttery beeswax and crayon fused.

A SERIOUS ART MATERIAL

Sweet faces and quirky characters fill the handmade sketchbooks of artist Lynne Hoppe. She had always been creative, but it wasn't until she reached the age of fifty, having burned out on an intense business of creating and marketing glass beads, that Hoppe discovered a more gratifying creative outlet.

She bought herself a blank book and a handful of Neocolor II crayons and never looked back. When she started, she was too intimidated to purchase real paints but felt she could give painting a go with watercolor crayons.

At that time, Hoppe didn't think of crayons as a serious art material, but she soon discovered their creaminess and vibrant pigment. She was taken with the way the pigment behaved on her substrates and credits crayons with enkindling the love affair she now has with painting.

When she draws, Hoppe often works with a crayon in her nondominant hand. By doing so, she instantly eliminates the unwelcome urge to be self-critical and a perfectionist. She loves the way these drawings look and believes the practice has helped her art and striking use of color evolve.

Hoppe likes to lay crayon color on thick, smearing the pigment with her finger or a blending stump. Although she does much of her work in transparent watercolors, she adds areas of crayon when she needs opaque color.

For the intense effects, Hoppe dips the crayon in water first and then applies the color "like a knife spreading warm butter." To achieve the softness that she likes in her images, she applies crayon on top of beeswax then warms the pigment slightly so the beeswax and crayon fuse.

Dream Imagery

Hoppe's tiny dreamlike paintings are created on a variety of substrates such as muslin, wood, hand-made papers, rocks, shells, and even tea bags. Her works are usually no larger than 5" x 7" (12.5 × 18 cm). When she sets out to paint, she rarely has a preconceived idea, but lets the painting take the direction it wants to take. The result is a collection of hundreds of tiny faces spilling from old books and journals.

Hoppe's evolution as an artist is closely tied to the outdoors. At one time, she was a forest ranger, and there is a national forest next to her home in northeastern California, which serves as her studio.

She loves to create wherever she is and her preferred setup is outdoors with her work on her lap. She finds that her crayons and little books are the perfect tools to bring along. When inspiration strikes, she's ready. "If something comes along that compromises my art time, I stop doing it," she says. "At 59, art comes first."

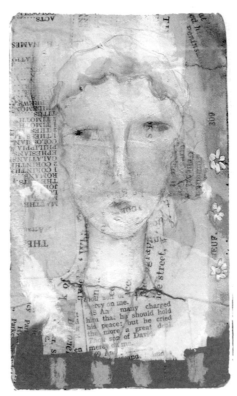

Lunette. Opaque crayon lines in stark contrast to dreamy skin tones.

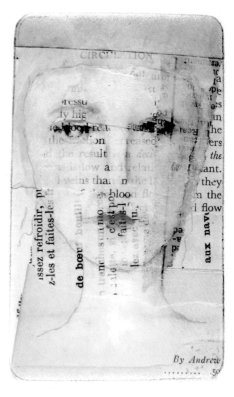

Holy Dolly. Crayon on top of watercolor paint.

PROJECT:
Soft Wax Crayon Drawing

One characteristic that distinguishes wax crayons from all other art materials is that wax softens and melts when it's warmed. That in itself may not be terribly interesting, but here is what is: The melted wax carries the pigment with it. With heat, you can move crayon color around, blend it, and work with it once it's been laid down.

I was intrigued with the idea of turning a drawing into fluid color and decided to find out what kind of control I could have over the blending. I created a picture on a birch-board substrate using a combination of techniques. First, I drew with the crayon on the board in the traditional way, then I used an artists' heat embossing tool to melt the crayon directly onto the wood.

There are two ways of doing this, I discovered. If you draw directly onto the bare wood, the crayon will leave a color stain in the wood grain as you move the wax around. This could provide an interesting transparent background for some drawings. If you don't want the stain, follow the directions in this project and prep the wood first with a coat of gesso or white acrylic paint.

Once you get started, experiment! Build up the color in thin layers. Blend and move the color with the embossing tool and a soft cloth, creating wax texture where you want it. If you don't like what you've done, simply heat the color, wipe it off the surface with the cloth, and start again.

Note
Be sure to use a wood surface for this technique—not paper. A heat embossing tool is much hotter than a hair dryer and could cause a sheet of paper to catch fire.

Tools and Materials

- 10" x 10" (25.5 × 25.5 cm) cradled birch artist's panel
- white acrylic paint or gesso
- bristle paintbrush
- soft lead pencil
- burnt umber acrylic paint
- sandpaper
- assorted wax crayons
- heat embossing tool
- muslin cloth
- black pencil
- soft flat paintbrush
- clear acrylic UV varnish

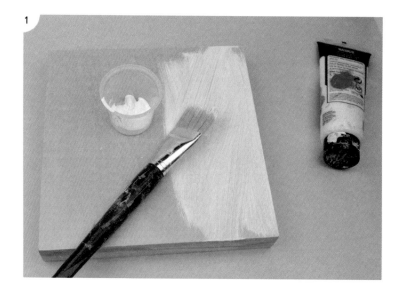

1. Paint the top and sides of the cradled birch board with a light coat of white acrylic paint. Allow the paint to dry thoroughly.

2. Use the pencil to make a rough sketch of your design on the board.

3. If desired, roughly paint the background of the design and sides of the board with burnt umber acrylic. Allow the paint to dry and then lightly sand the paint on the top, edges, and sides of the board. Allow some white from the primer to show through.

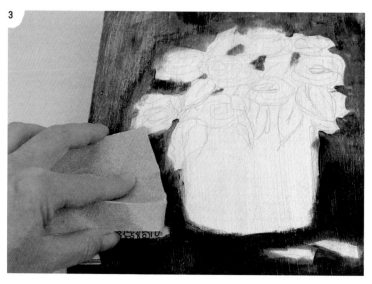

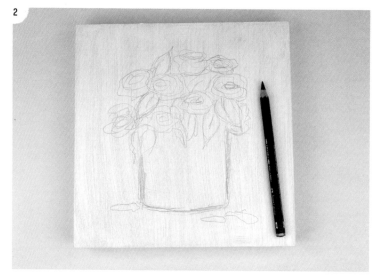

4. Lightly color the sketched design with crayons.

5. Using the heat embossing tool, blow hot air over the crayon marks. Hold the tool at least 1" (2.5 cm) from the surface of the board to prevent burning.

6, 7. Before the wax cools, blend the melted color with your finger, a brush, or a cloth. (Be careful, though, because crayon wax can be very hot.)

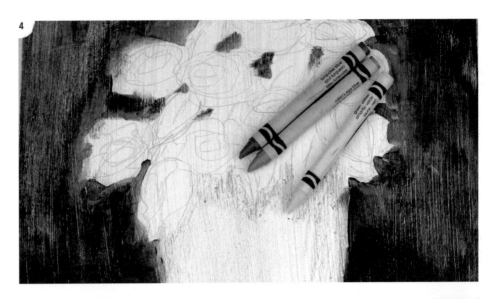

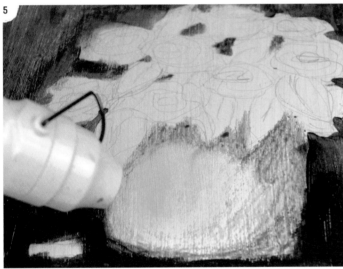

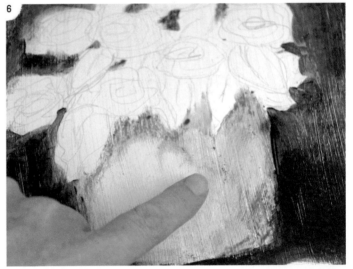

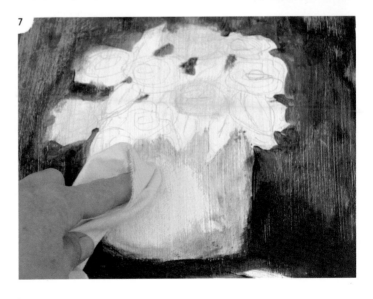

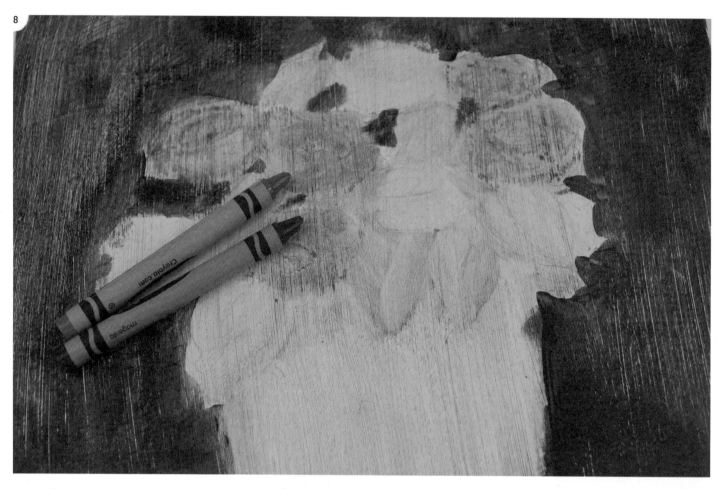

8

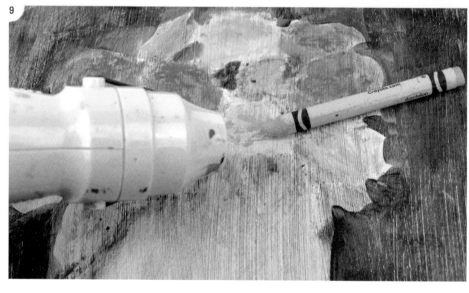

9

8. Pick up your crayons and add a new layer of richer color and shading. Heat the wax again and wipe it gently with a muslin cloth. The crayon marks will melt and blend into each other. Continue to add more color and heat in layers.

9. For added texture, hold a crayon a few inches above the image. Heat the tip of the crayon with the embossing tool and allow the wax to drip onto the board.

10. Once you're satisfied with the color and blending in your drawing, allow the wax to cool completely. Use the black pencil to sketch into the design to add definition and depth.

11. Use a soft bristle paintbrush to apply clear UV varnish over the surface. Allow the varnish to dry completely.

Note
Keep the drawing away from direct sunlight. Children's crayon colors are not lightfast and may fade over time.

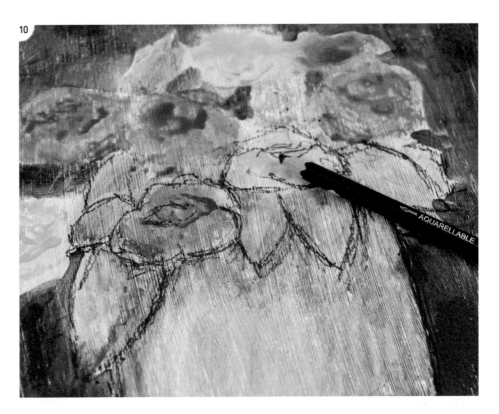

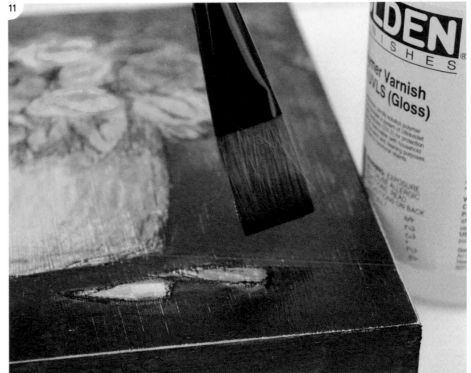

2

SCULPTURE

Melodie 47. Detail. Christian Faur used 2,000 hand-cast encaustic crayons in this 14" x 14" (36 × 36 cm) sculpture.

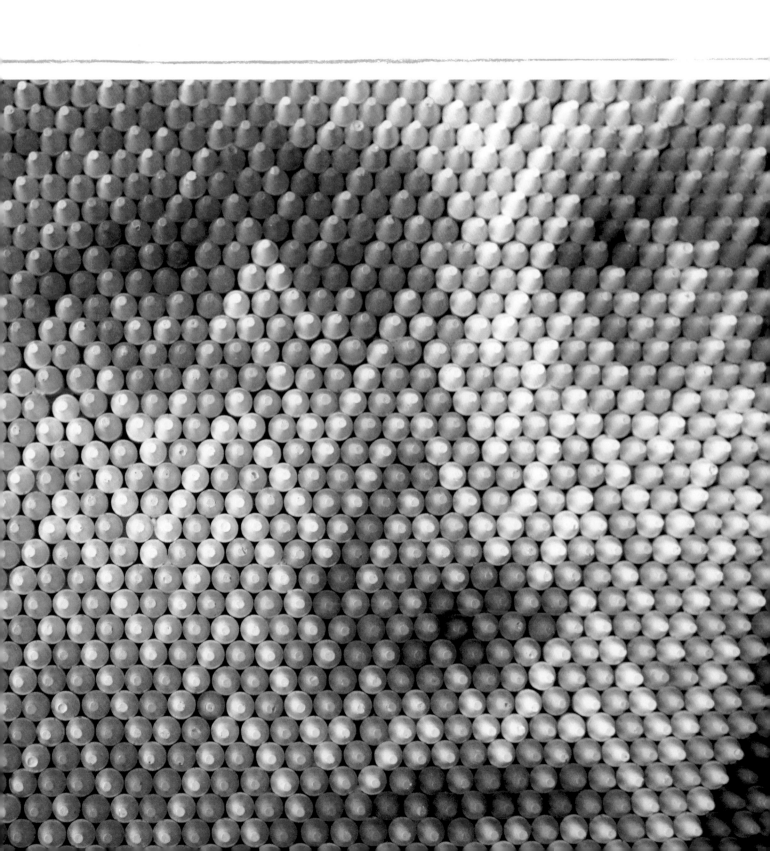

Introduction to Sculpture

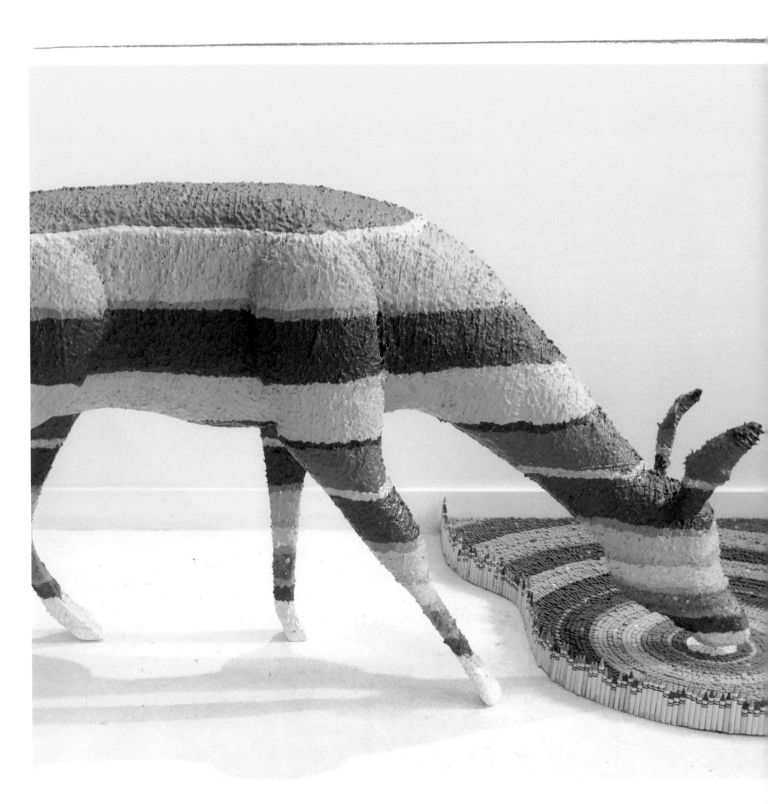

CRAYON CONSTRUCTIONS

The obvious thing to do with a crayon is to run the tip across a piece of paper to make marks. But not everyone does that when they pick up a crayon. There are visionaries among us who, instead of looking at what a crayon does, see what it is—a colorful stick of wax that can be used as a building block: a small, easily handled, if oddly shaped, brick.

The two artists in this chapter, Herb Williams from Nashville, and Christian Faur from Granville, Ohio, create colorful, figurative work in crayon, without ever drawing a single line. Instead they stack, layer, and cut crayons into submission, each in very different ways. Crayons, of all art materials, have the unique ability to lend themselves to artists in whatever form they're needed.

Creating additive sculpture with crayons necessitates using them in multiples, and that's where the view of crayon sculpture gets interesting. There is something mesmerizing in seeing tiny objects used over and over again in mathematical precision, to create something large—even installation size—seamlessly. As surprising as the final work of art may be, the sheer number of crayons, used so deliberately, makes it appear as if that sculpture was what the crayons were meant for in the first place.

Stacked and arranged, row upon row, by the hundreds or thousands—or even hundreds of thousands—all evenly lined up in a carefully chosen color sequence, crayons become something other than wax sticks. They appear as something other than the drawing tool we knew so well as children—and yet, that's exactly what they are.

Herb Williams buys Crayolas by the case and uses them with their iconic wrappers in place, further playing with our childhood associations. Christian Faur molds his own crayons, thus controlling the exact color, length, and weight of each one. It's the familiar crayon color tips that you remember poking out from a crayon box that you see in his pointillist portraits.

These are works that invite the audience to step in for a closer look. Once drawn in, you're left rubbing your eyes. As you will see on the following pages, these artists have used crayons every which way, except for coloring, leaving you to ask the question, "Is that really a crayon?"

The Ripple Effect. **From the Call of the Wild exhibit at the Rymer Gallery in Nashville. Photo credit: Dave Johnson.**

HERB WILLIAMS
IF YOU BUILD IT, THEY WILL COME

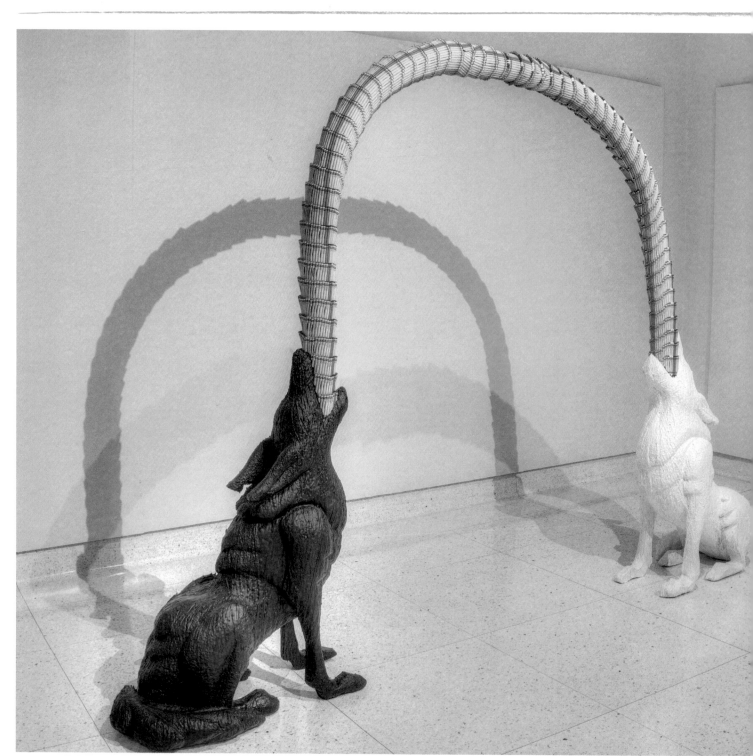

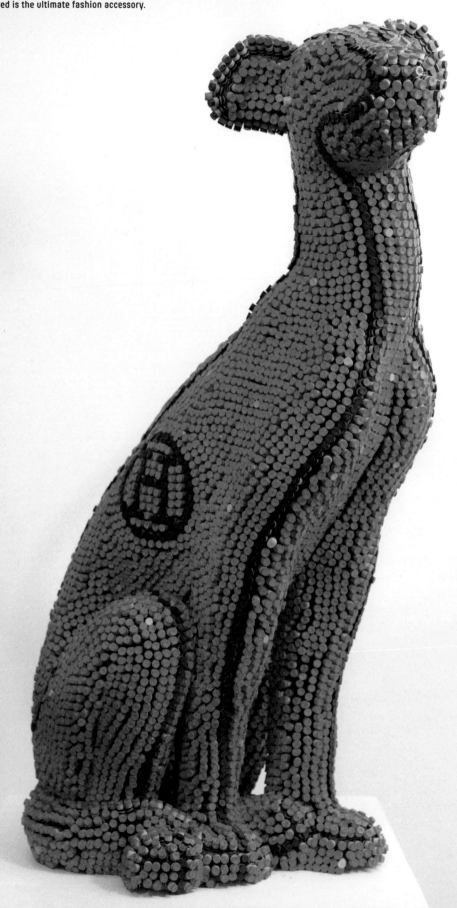

Hermes Whippet. This purebred is the ultimate fashion accessory.

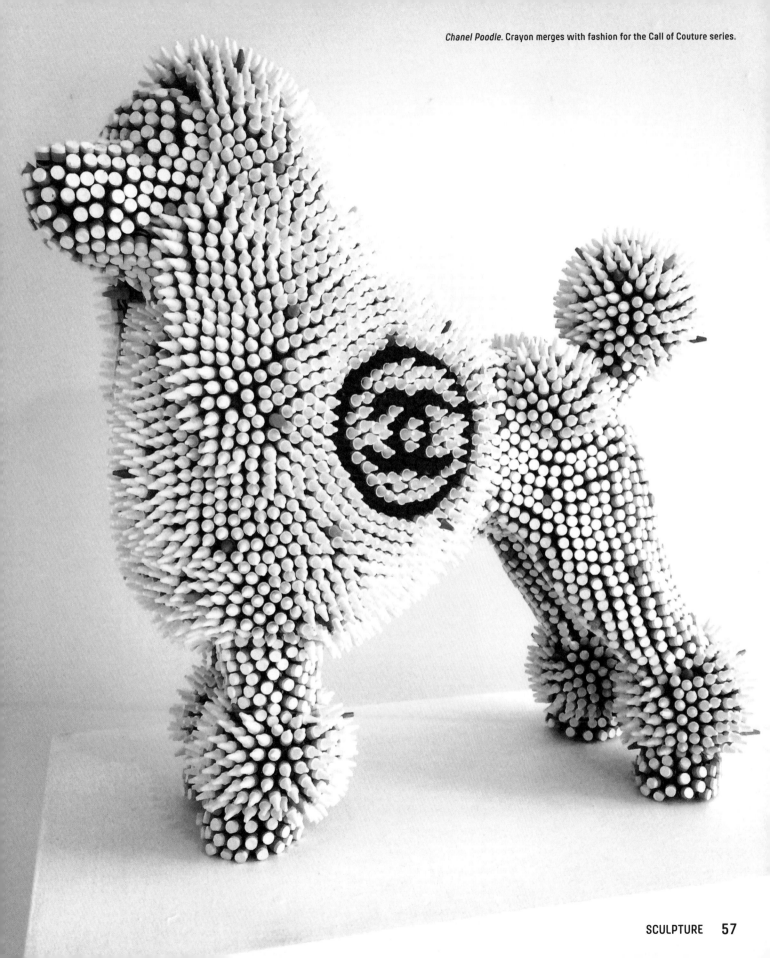

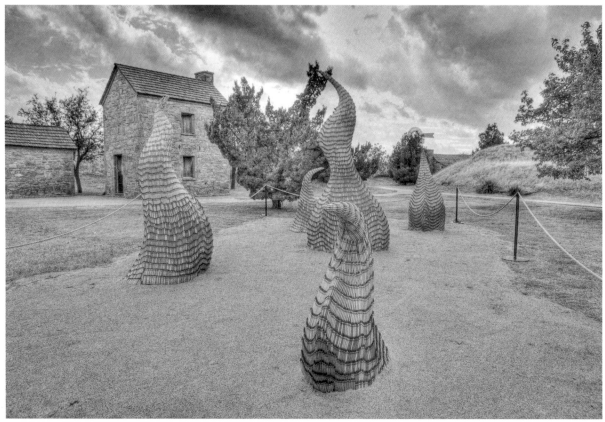

Ring of Fire. **Installation created for Texas Tech University exhibit. Photo credit: Ashton Thornhill.**

The Right Fit

Eventually Williams made his way to Nashville, where he now lives and works. He spent years sculpting and painting, using every material he could get his hands on, but never felt any of them were the right fit.

"No matter what I created, it had someone else's voice in it," he says. "I felt like I was standing on the shoulders of giants." For years he searched for a style of his own, but it wasn't until he began using crayon that Williams realized he'd finally found his medium.

"Crayons speak to commonality of the everyman," he says, "not just the art elite." And his sculptures draw everyone in. "People step over the threshold and are introduced to larger ideas. The work engages people and makes them hungry for a dialogue." The fact that most people have held a crayon in their hand automatically breaks down the barriers and invites them into the conversation. And Williams likes that everyman quality. His favorite tool for shaping crayons, he jokes, is an oversized dog toe-nail clipper.

Although Williams's artwork uses a material most people associate with childhood, it often addresses adult issues such as politics, religion, and sexuality. It's usually not until after those first moments of jaw-dropping disbelief—that juvenescence strikes. At this point, the viewer is fully invested. Every bit of that experience is by the artist's design.

Plunderland. A mythical fairy tale depicts rising from the ashes after the 2009 Wall Street collapse. More than 500,000 crayons were used for this installation.

A Psychedelic Honeycomb

Before a single crayon is ever lifted, Williams and his team create armatures for his sculpture, which are works of art in themselves. First, layers of laminated wood are stacked into large blocks. Then Williams uses a grinder and chainsaw blade to carve the blocks into the desired shapes. For larger sculptures, Williams uses fiberglass instead of wood to cut down on weight.

Many of Williams's sculptures use hundreds of thousands of crayons and can take weeks to complete. He's designed a jig that will hold 300 crayons that he can saw into matching pieces simultaneously to create what he calls a "psychedelic honeycomb." He glues wrapped crayons to his structures with industrial adhesive.

Another of Williams's special techniques is his method for melting crayon. He uses a pan attached to a heat gun that allows him to melt about six crayons at a time. If the wax is too hot, it can blacken and flare, so instead he methodically melts tiny bits at a time and allows the wax to fall onto his sculptures, drip by drip. This labor-intensive method helps Williams to build layers and striated patterns into his work.

Up in Flames

The installation that Williams is most proud of is his *Ring of Fire* that he created for an exhibit called "Unwanted Visitor: Portrait of Wildfire" at the National Ranching Heritage Center at Texas Tech University in Lubbock.

Williams designed five towering spirals of crayon in variegated flame-like shades to heighten awareness of the fires that ravaged the plains of Texas in 2011. Haunting and beautiful, his crayon flames were meant to slowly melt all summer in the Texas heat to reveal charred and blackened armatures underneath. By using crayon, Williams is able to use an ordinary implement to create extraordinary effects.

As the co-owner of the Rymer Gallery in Nashville, Williams plans to continue creating serious art that does not take itself too seriously. "Art is risk," he says. "Take the biggest risk you can."

PROJECT:
Crayon Sculpture

TALKING POINTS

It's probably fair to say that few of us will ever match the passion, precision, and expertise that Christian Faur and Herb Williams bring to their crayon sculpture. That's not to say we can't have fun with additive crayon sculpture on a more manageable scale.

The colors and shapes of crayon points have an iconic look that everyone recognizes. When they're trimmed from crayons and applied to another object where they don't belong, they bring a certain Dada-esque transformational humor with them—especially when they're densely applied.

I experimented with creating a punk crayon coif on a Styrofoam wig form, but the same application could turn another household object into a mini masterpiece. (Think of crayon-point–covered sunglasses, an old-fashioned landline phone, a pair of shoes, or even the sugar bowl on the breakfast table!)

Although anyone can tackle this technique and expect stellar results, it does require a certain amount of patience. A lot of crayon points are needed to cover even a small object: I used 600 for my Styrofoam head. I suggest looking for large boxes of cheap crayons at your local dollar store.

You'll need to trim the points individually, perhaps sort them by color, and apply them one at a time. But you can do all of these steps in stages over several days—no need for a 24-hour siege. You may find, as I did, that there is a certain restful quality to the repetition of placing and applying the points.

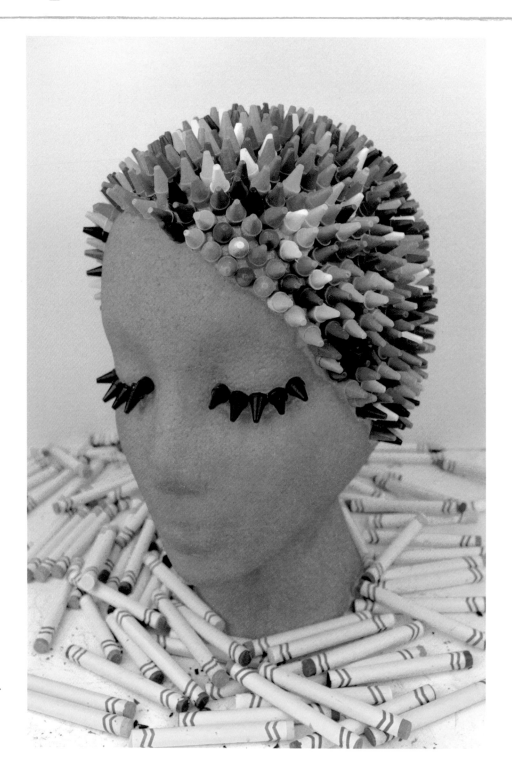

You'll need a sharp blade to get a clean cut when you trim the points. I recommend a box cutter with extra blades, or one that allows you to snap off the point with pliers, so that you can start fresh with a clean edge as often as you like. You might want to cover your work surface with brown paper or newsprint while you cut.

Working with a glue gun is out of the question for this project. The hot glue instantly melts the wax, and the crayon slides off before it sets up. Instead, use a quick-drying craft glue suitable for use on plastic, such as Quick Grip, Elmer's Craft Bond, or Aleene's Quick Dry Tacky Glue.

I went for a multicolored look for my project, but you can play with your color schemes and arrange your crayon points in stripes, for instance, or graded color. It's fun to watch the transformation of your base object take place. Then you get to think of clever ways to use the point-free crayons that remain!

Tools and Materials

- acrylic paint

- disposable sponge brush

- crayons

- box cutter with extra blades

- fast-drying thick, clear glue

- Styrofoam wig form

1. Paint the wig form with acrylic paint and allow it to dry. Apply a second coat of paint if needed.

2. While the paint is drying, cut the point off each crayon using a box cutter. Include about ⅛" (3 mm) of the crayon stick with the point. If the first few cuts shatter the point, stick with it. You'll quickly find the knack to aiming and placing the knife blade and how much pressure to apply.

3. Keep going! For this project, I needed 600 crayons to cover the wig form!

1
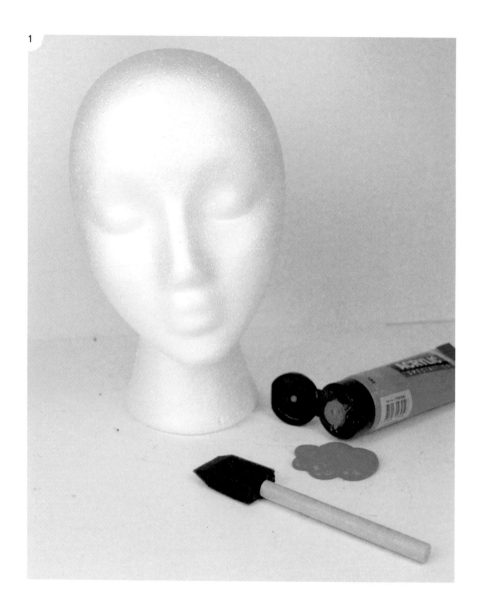

2
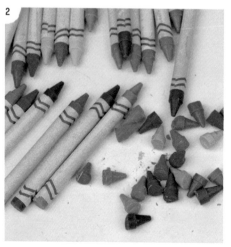

3

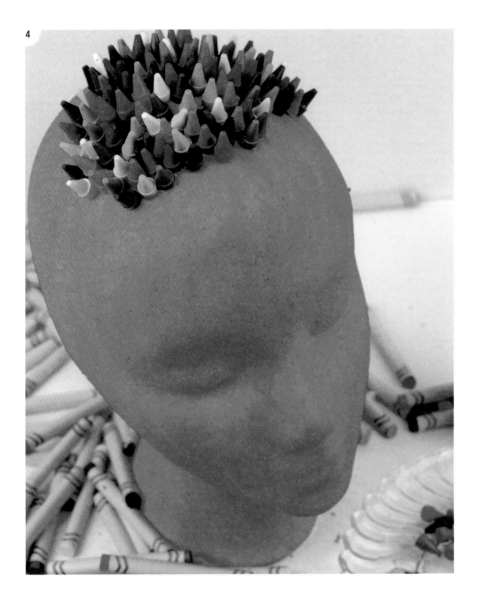

4. Starting in the center of the head and working outward, apply glue to a small area of the Styrofoam head. Working quickly, arrange crayon points on the glued area, as densely as possible. Alternate colors as you go or work in specific color arrangements.

5. Determine the hairline and make a neat edge.

6. If desired, give your model a dramatic pair of crayon-point false eyelashes.

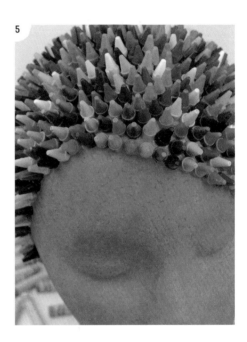

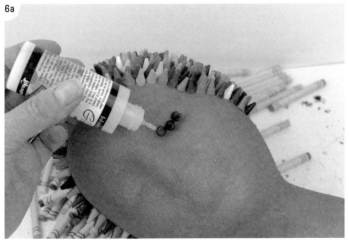

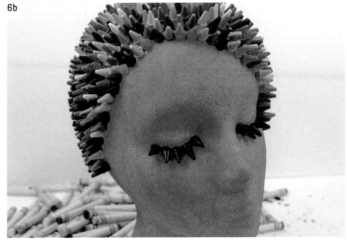

CHRISTIAN FAUR
GETTING TO THE POINT

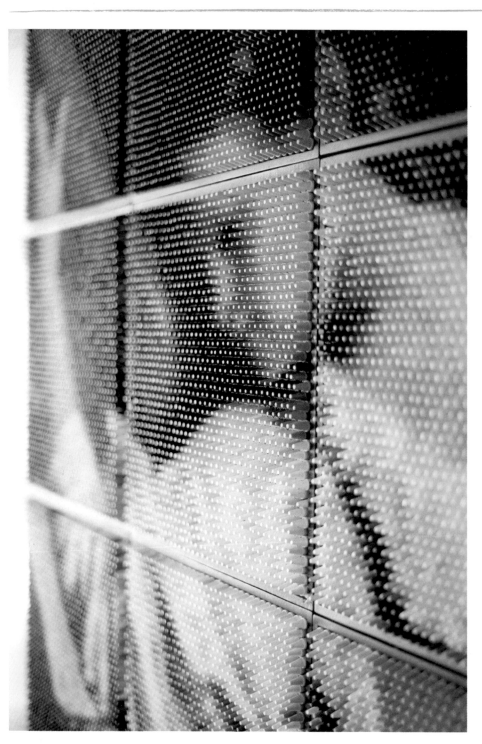

PIXELS, PARAMETERS, AND CRAYONS

In a world where common thinking tells us that you are either right-brained—artistic and creative—or left-brained—scientific and analytical—Christian Faur has crossed the line. Again and again.

His title at Denison University in Ohio, director of collaborative technologies for the fine and performing arts, is a mouthful. He prefers the title Maker. In his classroom, he teaches his students to combine art, computer science, mathematics, creativity, technology, and innovation. In his sculpture, he blends technology with art to create photorealistic portraits using a medium from his childhood.

Faur's path to his current work began at home, when he was building a box to hold his daughter's crayons. But when he looked at them, he didn't see what the average person sees—a rainbow of waxy sticks—instead he saw pixels, parameters, digital imagery, and a whole new way to play with crayons.

The Lute Player: An Homage to Gentileschi,
Faur created this masterpiece on nine panels with a total size of 36" × 36" (89 × 89 cm) using hand-cast encaustic crayons.

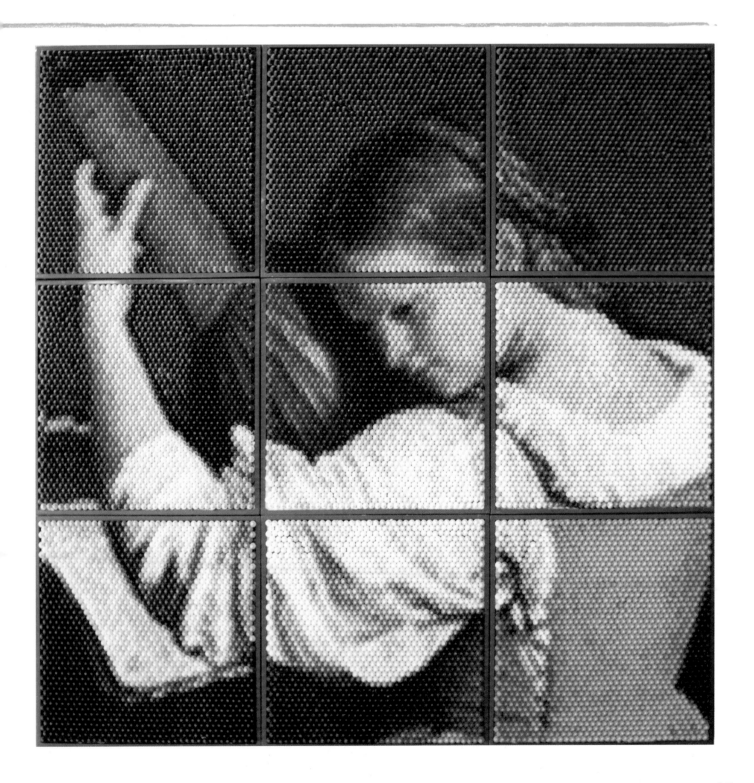

"My earliest memories of making art involve the use of wax crayons," Faur recalls. "I can still remember the pleasure of opening a new box: the distinct smell of the wax, the beautifully colored tips, everything still perfect and unused."

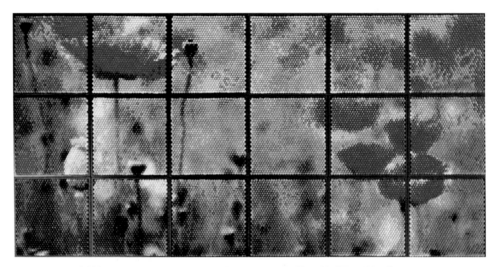

Poppies. Using 19,000 hand-cast encaustic crayons, Faur created this 30" × 60" (76 × 153 cm) piece on 18 panels.

Poppies. Detail.

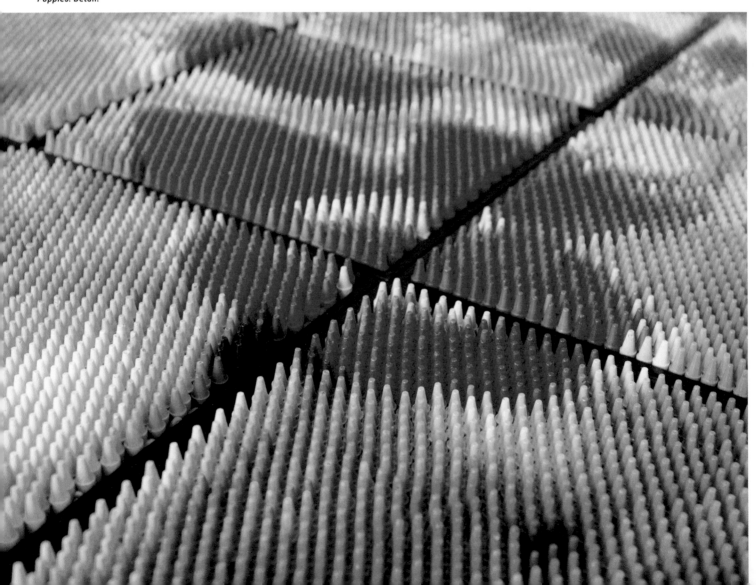

New Colors, Tints, and Shades

Struck with his new fascination, Faur spent three months developing tools, molds, methods, and a system for mapping crayon colors. Although he started with a grayscale, he eventually created colors, shades, and tints to coincide with the images he saw in print.

Faur pushes the crayon to say more than it ever has before. He translates his images in Photoshop by working with algorithms to determine the relationship between the color and each pixel.

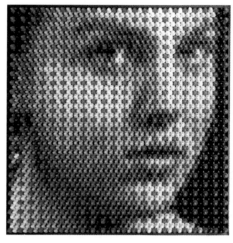

Melodie 22. Solid red and gray polka dots, approximately 2,000 hand-cast encaustic crayons, 14" × 14" (35.5 × 35.5 cm).

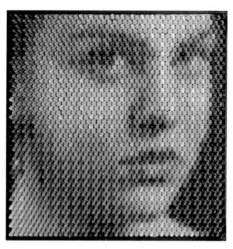

Melodie 19. Green and pink polka dots, approximately 2,000 hand-cast encaustic crayons, 14" × 14" (35.5 × 35.5 cm).

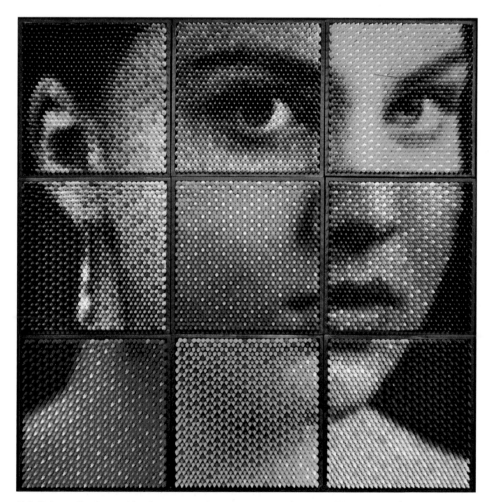

Melodie Large. Ten thousand hand-cast encaustic crayons were used to create this version of *Melodie* on 9 panels, measuring 31" × 31" (78.5 × 78.5 cm).

Melodie 47. Salmon zig-zag pattern.

These pieces are all part of *A Series of Melodies*, in which Faur used a "rule-based" approach with the same image of his daughter, Melodie. The installation of the series was shown at the Kim Foster Gallery in New York in 2012.

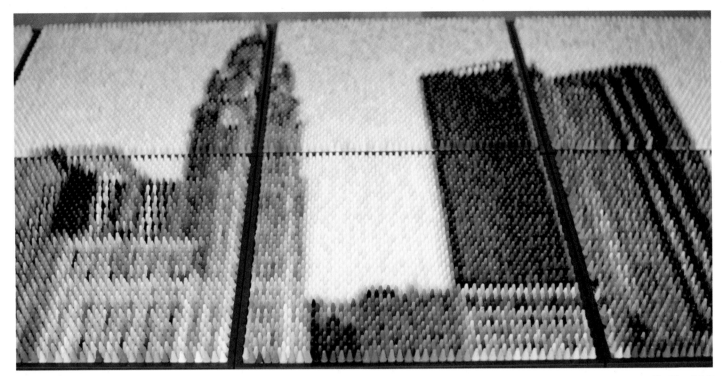

Sky Line, detail

Crayon Casting

Obsessed by sequence, Faur is able to manipulate the image and then re-create it in crayon—more precisely, the crayon tip. He searches for subtle shading and nuances at the digital level. Then he casts his own crayons in the colors he needs to create a palette that will give his images a painterly feel.

His casting mix is a formula he developed from Damar varnish crystals, beeswax, and artists' pigments. He melts and blends the ingredients in ordinary rice cookers, then pours the molten wax into silicone molds. Because his finished works are meant to be permanent, he pays particular attention to the hardness and light fastness of his wax so that his sculpture will endure for years to come.

Since Faur's focus is on using the points of crayons to achieve depth and dimension in his sculptures, he molds his crayons shorter than most. They are long enough to appear as a whole crayons, but the shorter length helps Faur contol the weight of his pieces and the difficulties of hanging them. His finished work is weighty. Typically, his large portraits contain 20,000 to 30,000 crayons, but some have as many as 120,000.

Sky Line. Faur used 30,000 hand-cast encaustic crayons to create this magnificent scene on 14 panels measuring 84" × 24" (213 × 61 cm).

Putting It All Together

Once Faur's imagery is mapped and his crayons are molded, he begins the process of standing the crayons upright in the appropriate spot inside a wooden frame. He works from the flat side of the crayons, stacking them in rows according to his map. But it gets complicated. Faur cannot use a 1:1 grid for placing the crayons because they are round and they fall in different places. So he has created equations to determine the proper placement of each.

Before completion, Faur sits with a completed piece for several weeks, studying it, looking for the odd color that's out of place, ensuring that the image works from every angle. Only then, when he's certain each color is right, he heats the back of the piece to fuse the crayons permanently, thus creating his ultimate box of crayons.

Choose Your Approach

Faur's haunting portraits have the grainy look of faded photos. As you approach the portrait, the juxtaposed dots of color mix optically and disappear completely. Another step closer and you realize you are looking at the tips of crayons. A few steps back and the brain redeciphers the pixelated image as a grainy photograph again.

And there's another thing you notice as you walk back and forth in front of one of Faur's works: they change dramatically at every angle. By taking into account the slope and color of the crayon points, Faur designs each piece to take on a completely different look depending on where you stand when you look at it.

Faur loves to make and explore and communicate. Before his crayon work evolved, he would incorporate mathematical elements into his paintings with backgrounds of tiny numbers, symbols, and equations. This was the "language" of his art.

Now he has similarly developed a crayon alphabet, much like a code, where each letter is represented by a color. Faur intersperses the crayon letters throughout each image, always including a key to the code in the lower left, inviting viewers to decipher the poem, statement, or story.

Faur communicates through the language of materials. He is quoted in *American Craft* magazine as saying, "I love playing, I feel like a kid." But although he approaches each piece as he would a game or puzzle to solve, make no mistake about it—Faur's artwork is not child's play.

3

CARVING

Golden Frog. Part of Diem Chau's
Precious Few series focusing on
endangered animals.

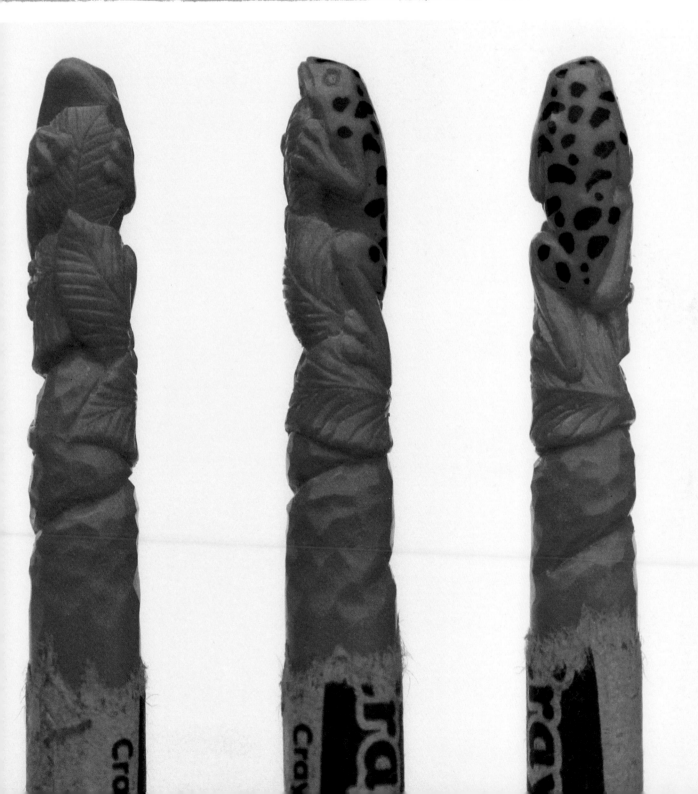

Introduction to Carving

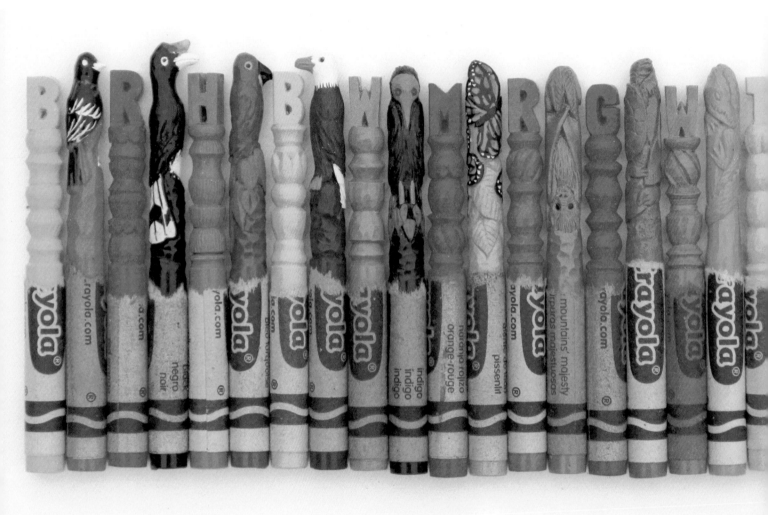

A group shot of endangered animals from Diem Chau's *Precious Few* series made for a collaboration with the Philadelphia Zoo

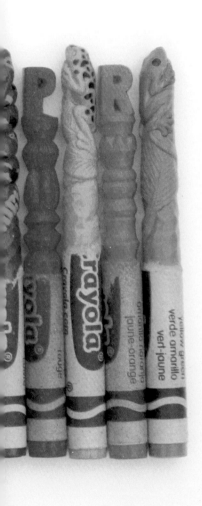

CHIPPING AWAY AT THE WAX

This chapter explores a little corner of the art world that many people don't even know exists—the art of crayon carving. Although the sculptures in this special corner are tiny, they become huge when you look at them closely. It's because of their perfection. They make you blink and shake your head. You can't wait to show them to someone else, and you laugh out loud because you can't believe what you're seeing.

Crayon carvers are indeed a unique breed. There simply aren't that many people who have the passion, the patience, the surgeon's skill, the magician's touch, and the slightly surreal outlook that allows them to pick up a crayon and think, "Maybe I can turn this into something else." Yet we have the work of three carvers on these pages: Diem Chau from Seattle; Pete Goldlust from Bisbee, Arizona; and Hoang Tran from Sunnyvale, California, all of whom have placed masterworks in that rarified little corner of the art world.

These artists tell their stories by painstakingly chipping, slicing, and piercing, until a tiny totem, or portrait, or geometric form emerges from a crayon. It's the control and the scale that astonishes, because, when you think of it, a crayon is in many ways an ideal material for carving. Wax is only semihard, after all, yet it's hard enough that you can carve away half of a crayon's mass and it will still stand tall. It's another one of those special qualities unique to crayons as an art material.

A carver's knives, blades, and mini-drills are not the typical tools of other artists who work with crayon. Working deftly, with steady hands and sometimes a magnifying lens, these artists find carving deeply gratifying, yet at the same time frustrating—one little slip and it's game over. Time to take a deep breath and start again.

But when it works, ah! What results is a tiny monument. There is something that appeals to all of us, carver and viewer alike, in taking something that is completely commonplace and overlooked, and turning it into something extraordinary with your own two hands. No matter what the subject, the fact that you've carved it from a skinny crayon takes it into the realm of brilliant conceptual art that everyone can appreciate. Not only that, this art form also allows you to play with knives.

DIEM CHAU
THE DELICACY OF TINY THINGS

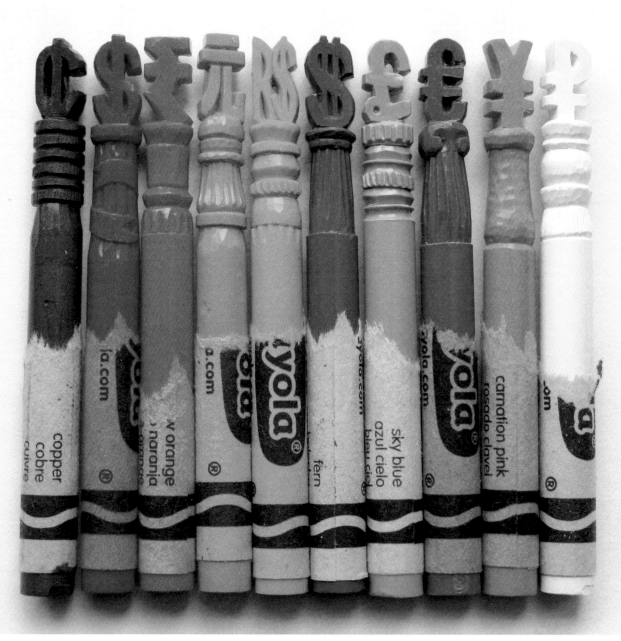

Currency. The collection is based on world currency symbols.

OBJECTS FROM EVERYDAY LIFE

Type "crayon carving" into an online search engine and, inevitably, Diem Chau's work will appear at the top of the list. The artist, based in Seattle, has an obsession with tiny things.

Chau started her miniature carving on the points of sharpened pencils and created toothpick sculptures before she decided to turn her well-honed knife toward crayons. Sculpting on a tiny scale allows her a comfortable intimacy with her work. She also feels that miniaturizing brings happiness to those who take a close look at her art, especially when using a medium that is familiar to all ages.

Born in Vietnam, Chau came to the United States as a child and, with few possessions, learned to make use of what she had. In the process, she magically turned practicality into creativity. "I embrace the idea that art is for all," she says. "To reflect this philosophy, the mediums I've chosen to use are objects from everyday life."

Chau, who has her B.F.A. in sculpture and painting from Cornish College of the Arts in Seattle, loves the connection between her art and items from her childhood. Her impressive style, brilliantly rethinking the way we look at these humble materials, has been noticed by corporations and organizations such as Nike, the Philadelphia Zoo, and Crayola, which have commissioned her work. Currently, when not carving crayons, she adheres delicate silk embroidery to porcelain plates and bowls to create graceful portraits.

A–Z: Northwest Natives. This alphabet series is based on species native to the Pacific Northwest.

Portraits A to Z

Chau's avant-garde approach to carving is in demand as she creates extraordinary portraits of people and pets with nimble care. She recently completed a collection entitled *A-Z: Northwest Natives* that was shown at the G. Gibson Gallery in Seattle.

As suggested in the title of the exhibition, Chau carved the letters of the alphabet with a coinciding natural inhabitant of the Northwest that had a name beginning with each letter. Her miniature masterpieces also appear in a commercial for U.S. Cellular, where the same theme of ordinary into extraordinary is front and center.

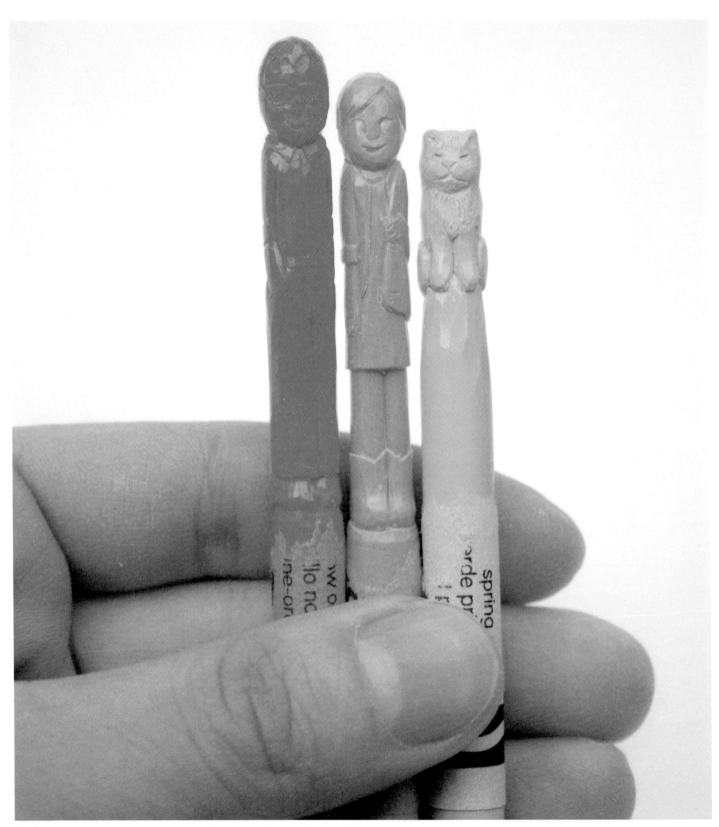

The Family. Carved crayon portrait commissioned by Keven McAlester and made in 2009.

Like Tiny Facets of a Gem

Carving is a meditative process for Chau. Her sculptures can take 3 to 4 hours to complete and, once she starts, she likes to stay focused on finishing. She often uses photos for reference and sometimes creates a rough draft carving to help her envision how her images will fit into the restrictive dimensions of a single crayon. Sometimes Chau also incorporates several colors in her pieces by a meticulous process of carving out a space to insert another color as an inlay.

Chau uses Hangi To knives, which are designed for Japanese woodcarving. She loves the effect the knife has on wax—each cut is like a tiny facet on a gem, leaving a shiny, smooth mark. Hangi To blades are not overly flexible, so Chau is able to control their movement, which helps avoid slips and crayon breakage. She admits it's happened, especially when she first started carving.

A slip of the knife or an unexpected air bubble in the wax will render a crayon completely useless. Because it cannot be repaired in any way, Chau has to start again from scratch. But first, to clear her mind, she slips into her garden and works to the point of physical exhaustion, which she believes is a cure for mental exhaustion. Then she's ready to move on.

Chau's crayon of choice is Crayola, because for her they represent a "ubiquitous symbol of youth, vibrancy, and pop culture." Crayola is to Chau what Campbell's Soup was to Warhol. She loves that they are buttery to cut, and the fact that they are instantly recognizable brings viewers in for a closer look.

Cortez. A commissioned pet portrait of a cat, created in 2010.

Diem Chau uses her Hangi To knife to create her tiny masterpieces. Photo credit: Des Haigh.

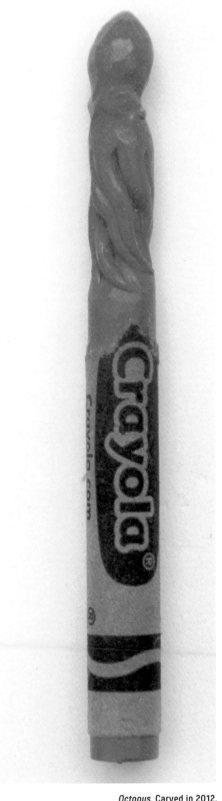

Octopus. Carved in 2012.

PETE GOLDLUST
INSPIRED IMAGERY

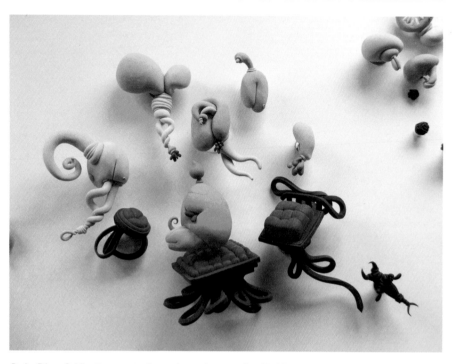

BreignFrieze. Goldlust's current polymer clay sculptures reflect his lifelong love of crayon color.

EVERYDAY EMBLEMS

"I try to make artwork that fosters a sense of wonder, joy, and play," sculptor Pete Goldlust says, "for myself and the viewer."

Is there any doubt that he's succeeded? These days Goldlust creates joyful, playful crawling things from polymer clay. "My work is rooted in cartoon-surrealist traditions, with Doctor Seuss and the comics thrown in," he explains.

Initially he established his reputation as a sculptural magician with his carved crayon talismans that leave you wondering, "How did he do that?"

While a graduate student at the School of the Art Institute of Chicago, Goldlust worked at the Roger Brown Study Collection and was influenced by the Chicago Imagists and their surreal, representational imagery.

He was surrounded by an incredible group of self-taught artists who had little or no money for supplies, yet he watched them create amazing works from everyday items. "I was inspired to look for sculptural material emblematic of my own life," he says.

Goldlust turned to the unassuming crayon as an iconic, common object, carving each as a sculptural reference to an art form or a familiar decorative motif. Whether they channel mainstream masterworks, such as Brancusi's *Endless Column* or the outsider techniques of chip-carved American tramp art, Goldlust's skilled carvings are master-pieces that fit in the palm of his hand.

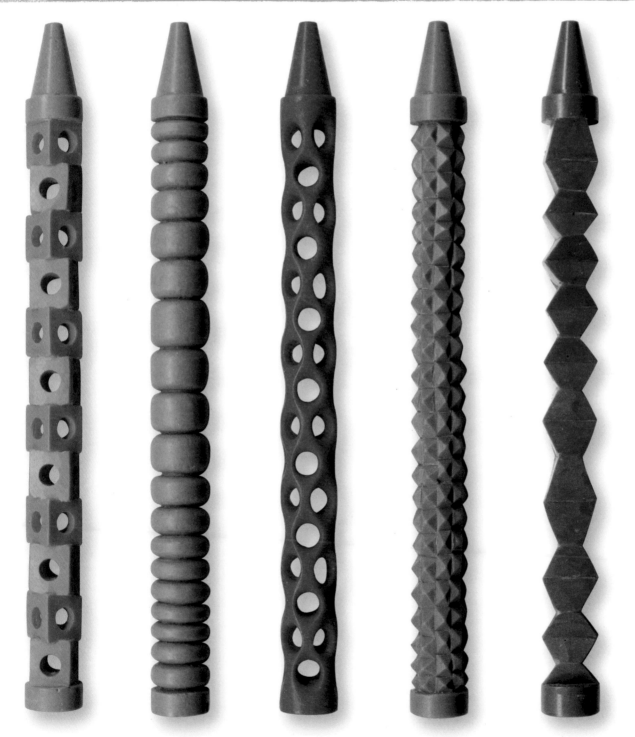

5Crayons3. From left to right, the crayons are named Robbin, Nib, Mamta, Em, and Branko.

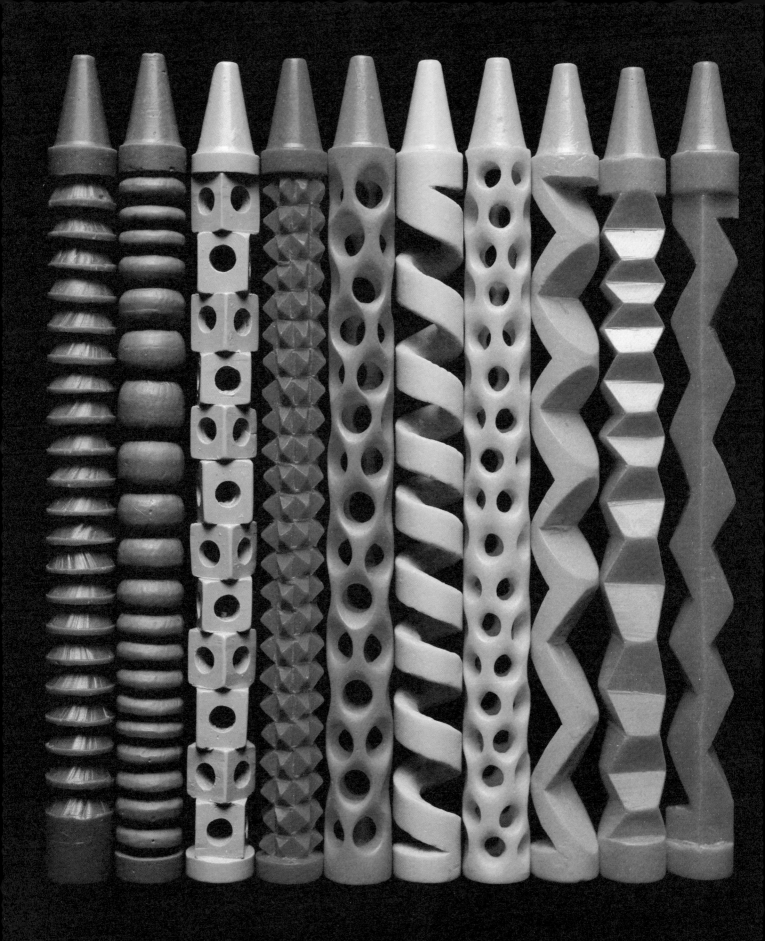

The Risk of Investment

"I just wanted to see if I could do it," Goldlust says about the inspiration that got him started on crayon carving. "It's a totally pointless skill to develop, and it's almost entirely untransferable to any income-generating activity."

Pointless? Maybe not. The creation of these pieces helped him stretch his thinking and skills in different directions at a time when he was searching for his place in the art world.

Working with craft knives and tiny drill bits, Goldlust invested fifteen or twenty hours a week into each carving. "The longer you work on a piece, the more time you've invested, so the riskier it gets," he explains.

Although he planned his designs ahead of time, "the goal was to get through it without breaking the crayon," he jokes. Not so funny: One mistake and he had to start all over again. "It was a good excuse to camp out on the couch for a week," he recalls.

Goldlust finished his pieces with a citrus-based product called Goo Gone, using the solvent on a cotton swab to soften the hard edges of the drilled and carved wax, and smooth the shapes.

Goldlust hasn't carved crayons in about ten years, although he still gets calls from curious enthusiasts and journalists who get excited when they come across his work. He now spends his time working in the public art arena, where he and his partner create murals and sculptures in open areas for everyone to enjoy.

As for crayon carving? Goldlust says, "The crayon pieces required a really calm atmosphere, where I wouldn't get startled by anything sneaking up on me, or biting me, or shrieking unexpectedly for no reason. That's probably why I stopped doing them—around the time I had kids!"

Ten Carved Crayons. From left to right, Goldlust showcases his masterpieces: Tree, Bub, Cane Toad (tribute to David Philpot and Bani Abidi), Tennis Crayon, Loud Century, Rind, Honey, Ray, Crushed Beehive, and Tramp. Photo credit: Amy MacWilliamson.

Polyjellies Room. Goldlust's most recent work, an overhead art installation created from recycled plasticware, hangs in a pediatric center.

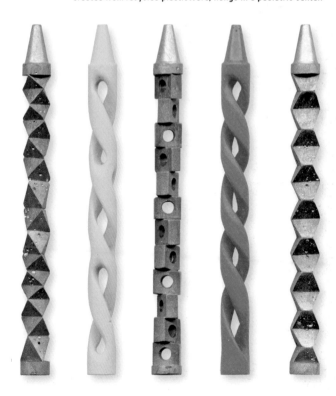

5Crayons2. From left to right: Diamelle, Mina, Knute, Gina, and Endless Crayon.

PROJECT:
How to Carve a Crayon

MAKING THE CUT: GETTING STARTED IN CRAYON CARVING

This is one field where the familiar phrase "they make it seem too easy" does not apply. What Diem Chau, Hoang Tran, and Pete Goldlust have achieved in their work does not look easy at all! Still, you can't help but wonder what it takes.

A steady hand and a good pair of magnifying glasses are a must for this project. I also recommend using jumbo crayons. My basic pumpkin-carving project is a good place to start, yet know that you may go through several crayons before completing this simple carving project! Don't give up!

This is an art that takes years of practice to master. Start small and keep practicing. You'll feel a sense of accomplishment as each little cut brings you closer to the finished form that you imagined.

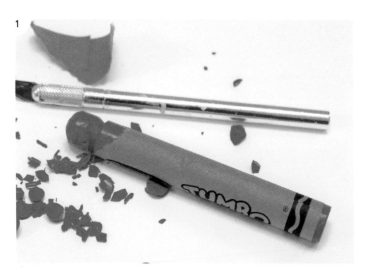

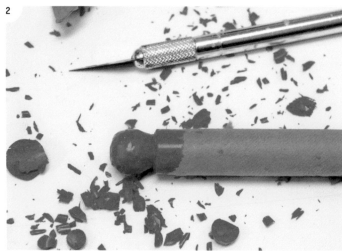

Tools and Materials

- jumbo crayons
- sharp, fine point craft knife
- bamboo skewer
- cotton swab
- citrus-based solvent (such as Goo Gone)
- tweezers
- candle
- clear craft glue

1. Peel back the crayon wrapper to reveal a section of the crayon. Use the knife to begin creating the rough shape of your carving. Make very shallow cuts with your knife. A deep cut is apt to cause the crayon to crack.

2. Slowly use the knife to shave away more of the wax to add definition to the shape.

3. Carve out details using a point of a bamboo skewer.

4. Smooth out knife cut marks using a cotton swab dipped in citrus-based solvent and gently rub over rough areas.

5. If desired, cut tiny leaf shapes out of a green crayon. To add the leaves to your pumpkin, hold bits of crayon over candle flame with tweezers to melt slightly.

6. Quickly place the leaves on the crayon. (If the pieces are too small to heat, use a tiny drop of clear craft glue.)

7. To display your tiny masterpiece, attach your crayon to a wood block with clear craft glue.

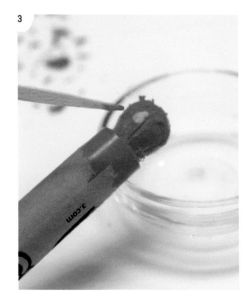

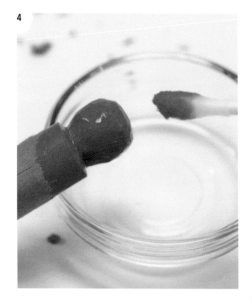

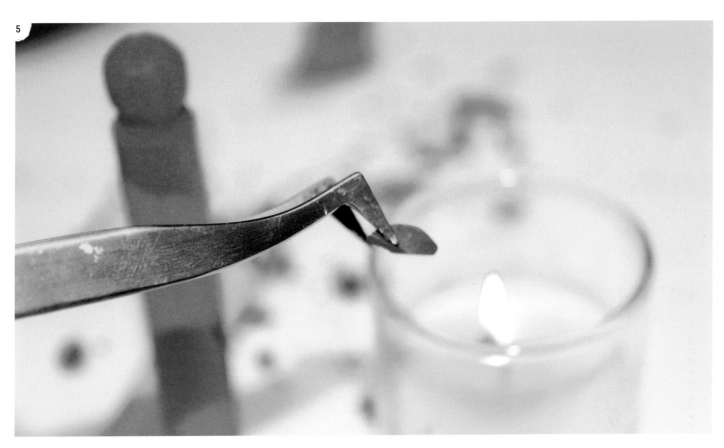

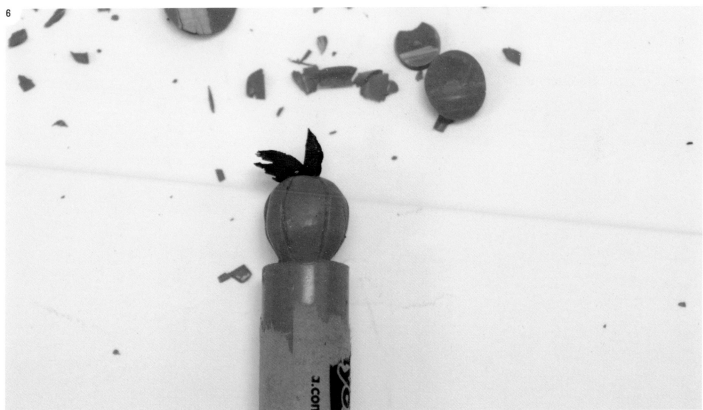

HOANG TRAN
CARVING HIS PLACE IN THE ART WORLD

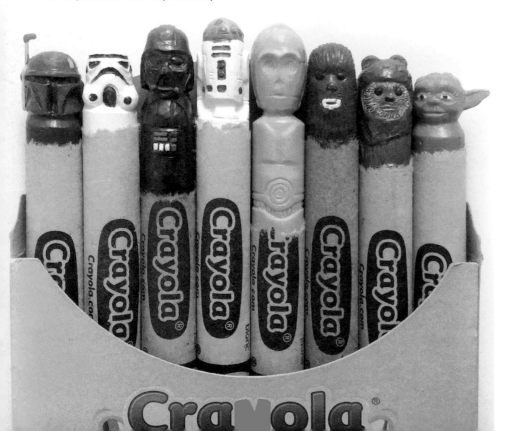

Tran's unique version of the Simpsons family

TINY POP ICONS

Hoang Tran's first career choice was dentistry. But things didn't go as planned. After three years of dental school, he realized it wasn't for him. He made the difficult decision to switch career paths.

It was at this point that Tran, a California native, felt he was ready for something more stimulating, something that would satisfy the creativity he'd had since childhood.

During his first year of dental school, Tran came across the work of fellow crayon carver, Diem Chau (whose work appears on pages 74 to 77). He was fascinated by the concept of carving crayons but, immersed in his studies, he was far too busy at the time to try it.

What intrigued Tran most about Chau's unusual artwork was the fact that he understood exactly what she was doing: He possessed the same skills. As a dental student, he was routinely required to carve teeth out of wax to learn dental anatomy and perfect his eye–hand skills.

When Tran picked up his dental tools once again, he wasn't carving teeth, he was carving crayons, creating intricate figures of pop culture icons from movies and TV. These remain his favorite subjects, but now he also carves custom pieces from crayon, such as wedding-cake toppers and portraits of pets.

An eight-pack of *Star Wars* characters

Waxing Nostalgic

Tran prefers to use jumbo Crayolas for his miniature statues; their stability allows him to achieve great detail. He usually leaves a bit of the wrapper on his creations because "the logo is iconic and easy for people to recognize," he says. "Crayola is also the brand I think most of us used growing up, so there's that nostalgia factor as well." Hence, the name of his art business—Waxing Nostalgic.

The carving process can take several hours for a single crayon. With some series, he also melts crayons to apply to his carvings like paint with tiny brushes. This additive technique adds an extra element of distinction to his tiny masterpieces as they gain personality with their color-detailed facial features and accessories.

The Anatomy of Crayons

Carving has given Tran a curious knowledge about the anatomy of crayons. He's discovered that crayons are not always the solid stick of wax they appear to be, but instead, as he digs deep with his microtools, he finds soft spots and minute air bubbles. These hidden booby traps can make the carving process tricky.

He's also noticed how each color reacts differently to melting and carving. Some colors change when the crayon is melted, some become shiny when the hot wax sets up, others cool down with a matte finish. Fascinating stuff for crayon fanatics!

Tran constantly tries to find new ways to perfect his craft for himself and his supportive fan base. There are not many crayon sculptors out there, and he enjoys carving out his niche in the art world.

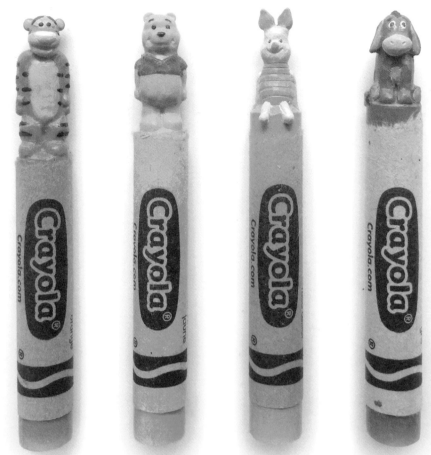

Familiar faces from *Winnie-the-Pooh*, carved and then colored with melted crayon

Pop culture characters from the *Adventure Time* television cartoon

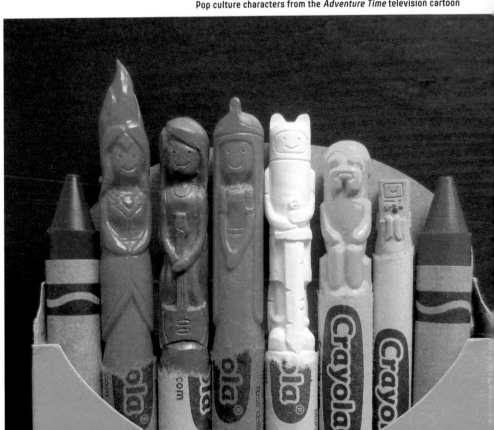

4

MIXED MEDIA

From a series by Jane Davies called
100 Drawings on Cheap Paper

Introduction to Mixed Media

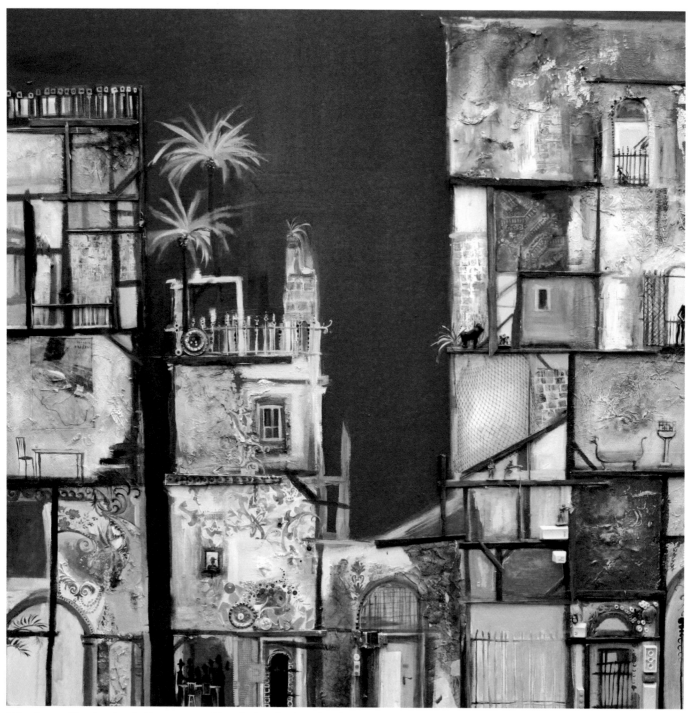

Cuban Dreams. There is a story inside every room of this mixed-media piece where Emmie van Biervliet used netting, wallpaper, toy soldiers, and buttons.

CRAYON BELOW
THE SURFACE

As simple an art tool as crayons might be, they're actually remarkably versatile. In fact, it would be hard to find a surface they won't write on: paper, cardboard, textiles, glass, wood, stone, concrete, and paintwork— crayons leave their mark on every one of them.

Straight from the box, crayons provide a means for scribing an outline, for working out a complete sketch, or for filling in an image with solid color. Depending on the type of crayons you choose and the result you desire, they resist water or blend with it: Drawn across a piece of paper, a crayon mark might appear as the simplest of lines at one end and a watercolor vista at the other. Add the element of heat, and crayon will bond with fabric, or take on an interesting transparency on paper.

All of these qualities make crayon an ideal medium for collage and mixed-media work. With crayon in hand, you can draw directly on canvas, on paper attached to canvas, over gesso and paints of all types, and on sculpted textures. A crayoned line can appear subtlely from underneath layered color and paper or more boldly on top, allowing you to model shapes, shadows, patterns, and add details and definition.

As mixed media has grown into one of the most universally popular methods for creating works of art in recent decades, drawing over layered canvases and constructions might seem to have grown up with it, but in fact the technique has been around for a while. When collage kicked off to its modern start in the early part of the twentieth century, artists including Braque, Schwitters, and Picasso were already drawing with crayon on top of cut paper applied to other substrates. And even before them, Degas experimented with drawing in crayon on top of oils and gouache to create softness in the contours of his subjects. It's immediate. It's versatile. It's readily at hand.

Grab a crayon and start experimenting.

JACQUELINE FEHL
DRAWING WHIMSY

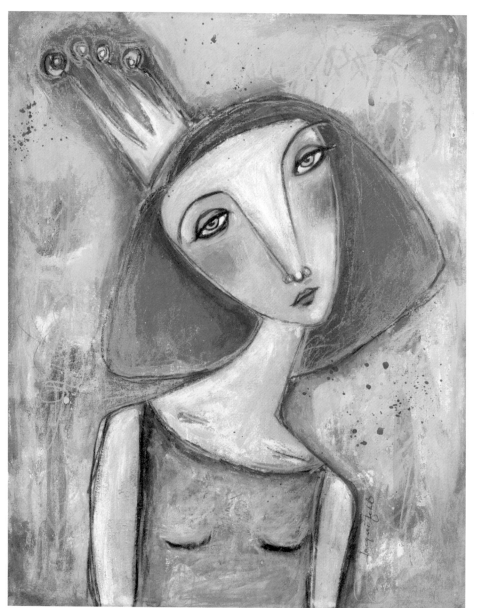

Violet Serving Up Queen Realness. Fehl's signature scribble and splatter are prevalent in this whimsical piece.

A HABIT OF MAKING STUFF

Mixed-media artist Jacqueline Fehl describes her use of crayon as a means of preventing her work from being too tight or precise. She is known for her quirky, whimsical pieces, with a layered buildup of paint, paper, vibrant drawing, and whatever she can get her hands on. Whenever she feels her work is becoming too serious, she scribbles a line with crayon to break up the uniformity or symmetry, as if breaking with the old childhood restriction of being told to color inside the lines.

Fehl grew up in Chicago and spent time in Los Angeles before moving to her beloved mountains of western North Carolina and picking up a paintbrush for the first time. Although she had previously worked with beading and fiber, it was through the internet and sites such as Pinterest that she began to discover the work of contemporary mixed-media artists all over the world.

Their work was different than the art she'd seen on the walls of museums, and she recognized something in it that excited her. The color palettes, movement of line, and freedom for variation and experiment kindled something in her. Perhaps that wasn't surprising as her entire background as an actor, voice coach, musician, fiber artist, and her lifelong habit of making stuff might be described as paving a mixed-media path that led to her present work.

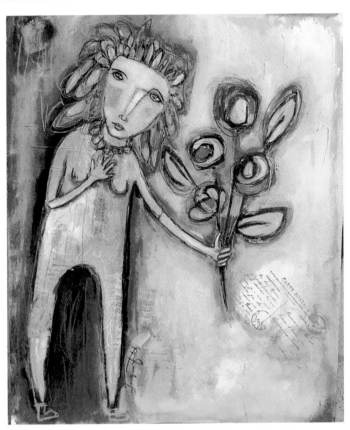

I'm Sorry. Strong crayon lines define areas around the figure and shapes.

An Element of Looseness

When she talks about her creative time, Fehl continually uses the words "play" and "explore" and the phrase "working without rules." She loves the primitive look of the crayon line and the way it adds an element of looseness to her work along with her signature splatters.

Like many artists, Fehl creates dozens of trial paintings before she gets to the one successful piece, "Failures are important," she says, "my best work happens when I remember to get out of my own way."

Her unique style comes from playing with both abstract and figurative form until she finds the perfect blend. "I never know what the finished work will be when I start," she says. So many layers are built up and removed again in the process, it would be impossible to predict the end result.

So that she doesn't have to stop while the layers are drying, Fehl often works on several pieces simultaneously, bringing an element of her life into each piece, telling part of a story. "It's up to the viewer to decide where the story goes," she says.

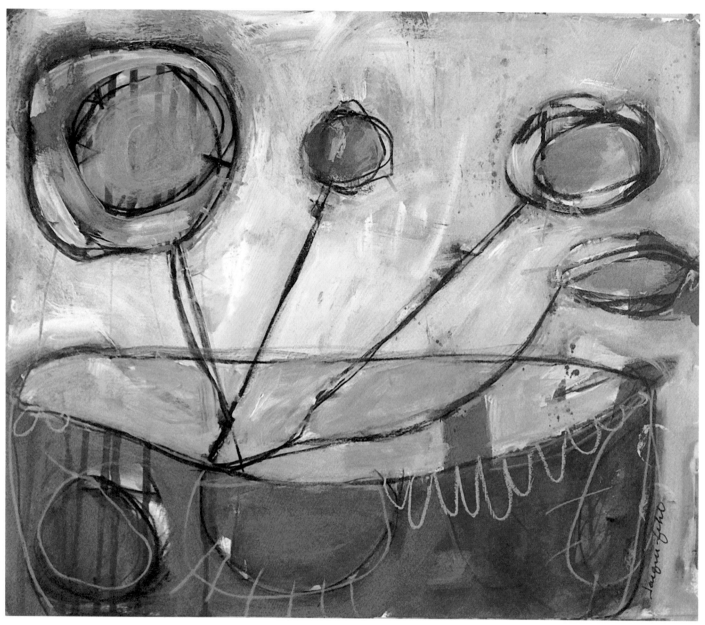

We Grow Together. Crayon color and line are used for definition.

This. Crayon line makes the forms and personalities stand out, and it also connects them.

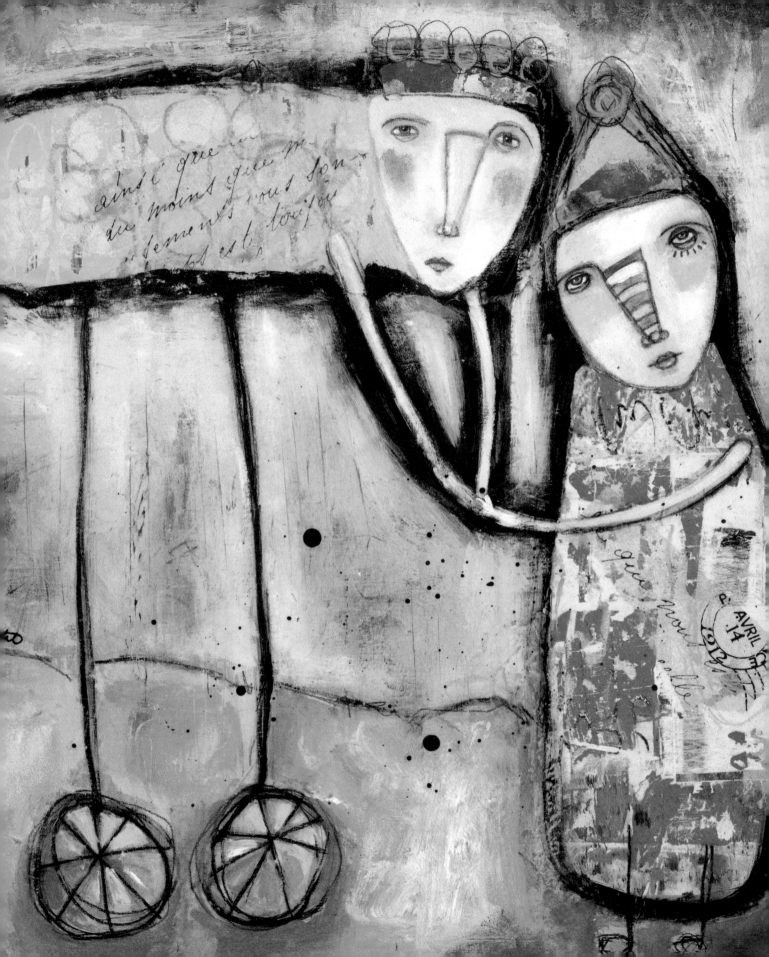

Jane Davies
COLOR AS LANGUAGE

Black and White no. 5. Davies likes to explore the absence of color by focusing on line, value, layering, and pattern.

AS IF IN A DIALOGUE

In looking at Jane Davies's mixed-media images, it's easy to forget that the painted acrylic and pencil line and crayon marks are only on the surface of the paper or board. The layers of color and line seem to penetrate, going deeply below the surface—the faintest lines like whispers or memories, the bright ones like new thoughts converging on the old, as if in a dialogue.

"My process involves a back-and-forth play between spontaneous, intuitive mark-making, and careful deliberation and intention," Davies says. "I make a move and then the painting reveals something new to respond to. Color is such a strong language in itself."

Sometimes she refers to the back-and-forth interaction in her work as a dance, sometimes a conversation, and you can feel the rhythms and reflections in the relationship between colors and the energy of the lines.

She uses Caran d'Ache Neocolor II crayons for much of her line work because the richness of the pigment balances so well with the vibrant acrylic color, and because the line value holds up and speaks quietly, but still clearly, under layers of paint.

Tumble Down. Davies uses a crayon mark as a connection in this piece.

These four images are from a series Davies calls *100 Drawings on Cheap Paper.*

Layering, Excavating, and Having Fun

Davies often works in series, starting several pieces at the same time with a single idea or focus, but allowing each to evolve individually at its own pace. In her series, *100 Drawings on Cheap Paper*, she set to work simultaneously on more than one drawing. Occasionally, one will emerge as a finished piece. To Davies, this series is about mark-making, layering, excavating—and having fun with the process. "Crayon is the quintessential art-making tool of the child," she says. "It's hard to look at a crayon mark without perceiving that reference on some level."

Davies combines making art with teaching workshops in painting, drawing, and collage around the country and online—a balance in her own life that she finds creatively fulfilling. Having started out as a potter in the early 1990s, she later made the transition into designing home décor and gift products. She freelanced, for about a decade, but something felt off to her.

"I realized I didn't know who I was as an artist," she says. So she began her journey into fine art, creating work for herself, teaching others, and helping them find a personal and playful approach to art.

Working in her studio in Vermont, Davies exhibits her drawings and collages a few times each year. But her online gallery is where she interacts with the public the most and where you'll always find her work.

Fresh Paint. Davies explores bright colors against neutrals in a cruciform format, using collage and painting.

PROJECT:
Crayon in the Mix

MIXED MEDIA WITH CRAYON ON BOARD

Your choices for working in mixed media are wide open: every variety of paper, all kinds of paint, plus crayon, pencil, chalk, stencils, and markers—it's up to you. The materials you choose, and the order in which you use them, determine what direction your work will take.

You might begin with crayon on paper, add paint, collage, more paint, and end up drawing in crayon again on top. In fact most mixed-media pieces are built in layers, so your piece will be in a constant state of change—almost as though it's talking back to you. If you're stumped, you can walk away from it, come back to it later, and pick up the conversation where you left off. With each layer and every change, your work offers you a new challenge. Ready? Relax, dig in, and have fun with it.

Cradled and plain birch boards

Choosing a Base

Your many choices in mixed media begin with the base or substrate. You can work on paper, stretched canvas, canvas board, cardboard, illustration board, or wood. My personal favorite is birch board, which is available in standard sizes in art supply shops, cradled (on a base) or plain.

Consider the Paper's Weight

If you decide to work on paper, be sure to choose a paper heavy enough to hold up to moisture and layers of paint, gesso, and glue.

Bristol paper has a good weight, and its smooth surface is great for crayon and pencil work as well as most other mediums. Bristol is also available mounted on illustration board, which provides extra strength and a firm backing for work that includes a lot of paint or collage. Other choices include watercolor paper, either hot pressed, which is smooth, or cold pressed, which has a textured surface.

Keep in mind, you're not limited to a white background. Starting with a dark or toned background can lead your work in new directions and toward new color choices. Papers with interesting textures, fibers, or patterns can also be mounted on board for extra strength if you choose to use one as your base.

Tools and Materials

- birch board
- gesso
- brushes
- paper ephemera (sheet music, book, or magazine pages, wrapping paper, etc.)
- scissors
- gel medium or paper paste
- acrylic paint
- painted paper
- crayons
- soft or aquarellable pencil
- spray fixative

1. Brush gesso onto the board as a primer. This will give you a beautiful base to work from. You can brush it on thinly and sand it for a satin-smooth surface, or paint on several layers of gesso in varying thicknesses to create a textured surface with brushstrokes.

2. Cut out or tear pieces of the paper ephemera. Use random shapes, controlled shapes, patterns, or details. Try not to overthink the process of placing the pieces on the board. Mix torn pieces with cut pieces to break up uniformity. Turn pieces with text upside down or sideways, and mix up varying shades of aging paper. Apply the paper to the gessoed surface with gel medium or paper paste.

3. Add color. Brush on acrylic paints in colors that work for you. Choose contrasting or complementary colors. Blend the colors in some areas. Apply the paint with a light touch so that it remains transparent and allows you to see the paper patterns underneath.

4. Make cutouts from the painted paper. These can be painted shapes and details that you prepare especially for this project, or bits from old drawings and paintings that you've set aside. Attach them over the painted areas with gel medium or paper paste.

5. When the painted and glued areas have dried, get out your crayons. I like to work with a contrasting color and scribble on quick, random lines. The crayon can act as a visual string to tie the entire piece together. It's your choice whether to work with water-resistant or water-soluble crayon.

6. Add stand-out areas of drawing with a dark-leaded pencil or an aquarellable pencil. I alternated the dark marks with white crayon. Your crayon and pencil work can be simple scribbles, doodles, handwriting, or lines.

7. When you're pleased with your composition, spray it with fixative to seal the work. You will still be able to add more drawing or cutouts if you change your mind, but the crayon and pencil lines will be protected from accidental smears or moisture.

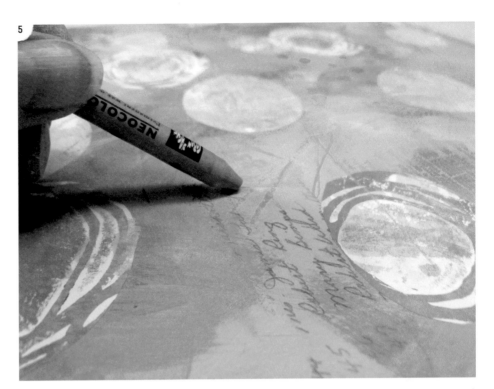

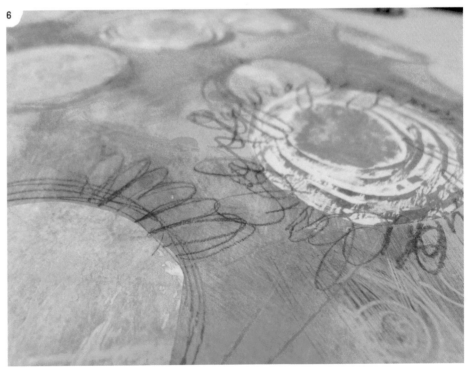

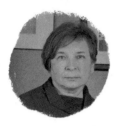

ELENA NOSYREVA
WHEN SCIENCE AND ART COLLIDE

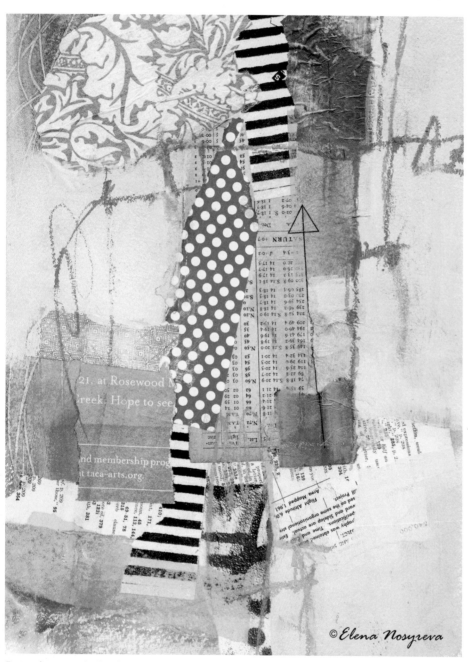

Foxtrot. Crayon marks tie colors together.

EQUAL CURIOSITY

Born and raised in St. Petersburg, Russia, Elena Nosyreva now makes her home in Dallas. By day, she is a neuroscientist who works on research at a cellular level. Not the typical image one would have of an artist but once you see Nosyreva's work, you understand the correlation she draws between art and science.

"The creative mind and the scientific mind are equally curious when it comes to problem solving," Nosyreva explains. Curiosity equals creativity. "Like scientists, artists ask the questions, 'What if?' and 'Why not?'" These are the questions that compel her to push herself when she is composing her studies. She approaches each piece with a sense of experimentation.

City Poetry. Crayons complement graffiti in this collection of collaged urban photographs.

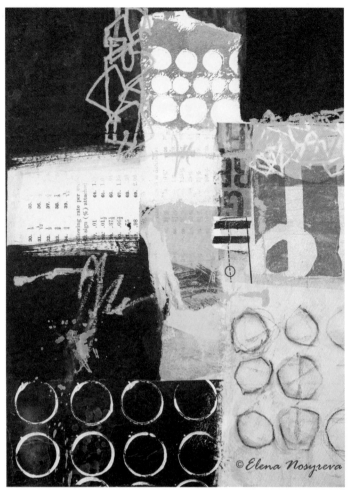

Circular. Bold crayon marks add contrast to circles.

Unexpected Solutions

Nosyreva's work usually starts with a question or a problem to be solved. To create art that moves the viewer, she focuses on how to build her art, instead of intuitively putting paint on paper.

She's decisive about her composition and the materials she reaches for, using precision in dissecting even the smallest element. While Nosyreva breaks down the construction of a piece, she finds unexpected solutions, which in turn push her artistic abilities to new levels. Just as a scientific researcher will collect data to get results, Nosyreva sets about to test her ideas artistically.

One such idea was to use crayon on her collaged photographs. Crayon adds layers to her compositions and also connects disparate pieces. The mark of a simple crayon line can sometimes be enough to tie the entire piece together.

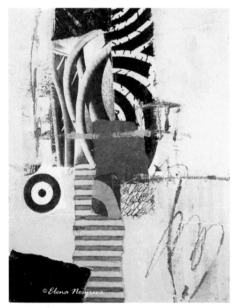

Target. Bold blue crayon marks complement striking black shapes.

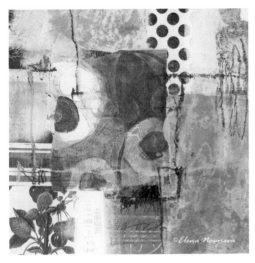

Sour Cherry. Crayon washes in green blend well with bold black and blue crayon lines.

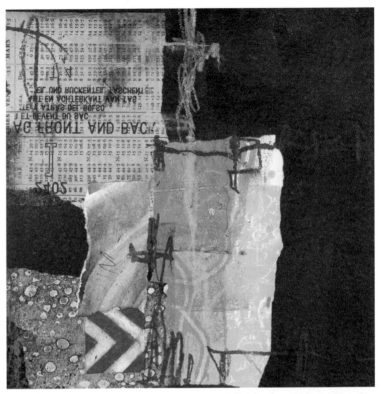

Back and Around. Disjointed crayon lines add energy.

Artistic Messiness

Nosyreva reaches for the vibrancy of Neocolor II crayons to emphasize elements in her work. She is fond of dipping her crayons in water for several seconds to soften them before dragging them across a page typically covered in acrylic paint. This technique allows for different widths of lines and the ability to move or blur color.

She can also subtract color, because the crayon offers her the flexibility of simply wiping it off. This "artistic messiness" gives her the freedom to experiment without making a final commitment until she feels it's just right.

Nosyreva's analytical approach to her art does not prohibit her from being spontaneous. She's the first to admit that she doesn't always have an explanation for what she does. "No one knows what an artist goes through," she says. "There isn't always a reason, sometimes it just is. It's like air, you just breathe. It's the same with art."

Experimentation with photography, digital art, and collage have proven to be a successful combination for Nosyreva and they now encompass the body of her work. All that testing and mixing of mediums, she says, can be attributed to her scientific mind.

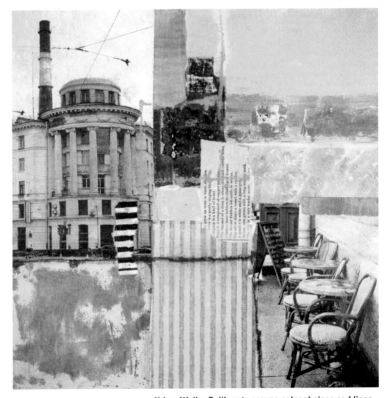

Urban Walks. Deliberate crayon color choices and lines tie together Nosyreva's photographic elements.

EMMIE VAN BIERVLIET
HAVE CRAYON, WILL TRAVEL

Aya Sofia by Night. Created on board with gold leaf, acrylic paint, papers, and tissue with the details drawn in crayon.

TRAVELING ENCOUNTERS

Emmie van Biervliet can be found painting anywhere from an underground city in a cave in Cappadocia, Turkey, to a street of crumbling buildings in Havana.

Her artistic journey correlates directly with her personal journey as she bounces around the globe, always carrying crayons in her traveling art kit.

Based in Bristol, England, van Biervliet is known internationally for her quirky, mixed-media, architectural paintings. As part of her wanderlust, she loves to immerse herself in local culture and hear the stories of the people she encounters and the places she visits. Inevitably, the stories end up as a part of her work. Van Biervliet's art often encompasses magical realism, mystical tales, and bizarre images, all encountered during her travels.

Van Biervliet's process is to sketch and photograph wherever she goes. She approaches a potential subject from every angle, looking for subtleties in the structures around her. She will often combine ideas from two different cities, or even countries, into one painting, re-creating the scene the way she sees it in her mind's eye. She describes each window or doorway as having a history and a future, and she weaves her story through theirs into her renderings.

La Penne by Night. Food wrappers were incorporated into the acrylic paint and details were drawn and scraped on with crayon.

The Portability of Crayon

Wherever she goes, van Biervliet collects bits and pieces, such as paper, maps, stamps, spices, coffee—even earth—that she incorporates into her work. She creates much of the foundation for each piece on site, and she loves the portability of a crayon. Inspiration can strike anywhere and anytime, and as van Biervliet has discovered, "Crayons are ready at any moment in your bag."

Van Biervliet sometimes attracts a crowd as she sits in the open to work. Her spectators are often willing to offer her perspective or historical information, thus adding to her story. Many times, curious children will gather around and van Biervliet says, "having an ample supply of crayons means you can easily spare some and share your passion and way of seeing the world through drawing."

The Simplest of Art Tools

"Crayons are professional *and* they're childlike," van Biervliet explains. Typically, she uses them to loosen up as she begins a sketch. Because her work is highly dimensional, she uses the side of a crayon to hit high spots and uses the point for details and the waxy line as a resist with paint.

More unusually, van Biervliet will carve into the side of a crayon, creating gouges and divots. Then she draws with it on top of acrylic on board, to create a greater variety of marks in her work. All of that from the simplest of art tools.

Van Biervliet spends much of the year in residence at different art communities around the world, but is now renovating an old building of her own in the United Kingdom. This may slow her down a bit, but she is certain there are many stories inside her old building, just waiting to find their way out and into her artwork.

Calle Mixta. In this monochromatic piece, van Biervleit used crayon, acrylic, and gesso, creating much of the texture by rolling a paper cup across the surface.

Porto Church of Sao Francisco. The main elements were created and cut out of mat board, stained with coffee, while the details were done in crayon and pencil.

A Tale of Two Cities. Van Biervliet created a marriage of two favored cities, Istanbul and Marrakesh, and used a rolled crayon for shading.

MARY JANE CHADBOURNE
DESERT DREAMS

Art vs Fantasie. Blended crayon is used in the background of this piece to make darker images pop.

THE INFLUENCE OF COLOR

"Using crayons is fun," Mary Jane Chadbourne says in talking about one of her favorite creative tools. She pulls her inspiration from her surroundings in the desert near Las Vegas, where she works out of a charmingly compact 10' × 10' (3 × 3 m) studio that her husband, James, built for her. This is where the magic happens.

Chadbourne's work hasn't always been so focused on color. While living in Long Island, New York, she studied fine art and became obsessed with pencil and pen-and-ink drawings. She worked strictly in those mediums for so long that she was terrified to use color. That changed when she left the city and moved west. Her prismatic art soon followed her move. The colors she uses most in her palette—rusts, oranges, turquoise, and blues—derive from the intense colors of the desert around her.

Desert Dreams Studio, built by James Chadbourne

My Five Cents Worth, mixed-media collage, 2012

Spoken Soul Cards. Crayon work makes up the background of these sanded and painted playing cards.

Painting Faces

Chadbourne became intrigued by crayon when she started painting faces. Challenged by facial coloring, she sought a medium that would allow her to layer many colors to achieve the skin tones she desired. She found, with patience, that she could create veils of transparent color with water and crayon to achieve the depth she wanted.

Chadbourne usually reaches for Neocolor II water-soluble crayons for her mixed-media work. She uses crayon in the backgrounds and describes this foundation as the glue that holds an entire piece together. She loves the effect she gets when she layers wet crayon on top of collaged bits of ephemera. The crayon becomes transparent, allowing the collaged medium to show through subtly while also highlighting the textures.

One thing Chadbourne likes about crayon is that she can use it on almost any substrate. She blends crayon on canvas, wood, paper, and even a deck of playing cards. Her *Spoken Soul* cards are inscribed with bits of wisdom to be given away, but she also creates entire decks of cards, housing them in beautifully adorned boxes.

Chadbourne is probably best known for her explosively colorful shrines and quirky art dolls. For these, she collaborates with her husband, who cuts the forms from blocks of wood that she'll build with and embellish. She uses words such as *secret* and *mysterious* to describe many of her pieces. Sometimes they contain vague hidden or Latin messages, leaving interpretation up to the viewer.

In her online classes, Chadbourne encourages her students to let go of fear and just play. She teaches with crayons for that very reason. "With crayons," she says, "there is very little chance that you will have a serious error."

Serengeti Dreams. A wash of multiple crayon colors gives transparency and emphasizes texture.

PROJECT:
3-D Mixed Media Treasure Box

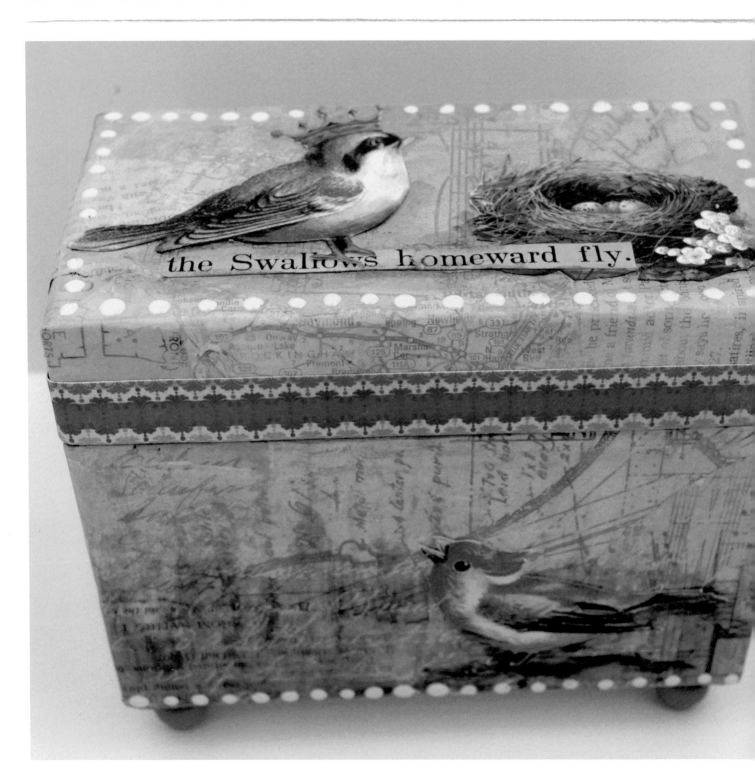

the Swallows homeward fly.

QUIRKY BEAUTY

I was fortunate enough to take a class with Mary Jane Chadbourne a few years ago and learned to make her Spoken Soul cards and a "house" to hold them all. I loved her use of crayons and the idea of creating a dimensional shrine or icon. I decided to use a few of her techniques to create a beautiful and quirky box to demonstrate how crayons can be used in a nontraditional way.

Tools and Materials

- hinged papier-mâché box
- white gesso
- foam brush
- paper ephemera from old books, sheet music, road maps, and printed tissue paper
- gel medium for adhesive
- baby wipes
- Caran d'Ache Neocolor II crayons (water soluble)
- paintbrush, soft oval
- rubber stamps
- waterproof stamp pad
- spray fixative
- heat gun
- scrap printed paper
- 4 wooden knobs
- acrylic paint
- dimensional paint
- craft glue
- gloss varnish

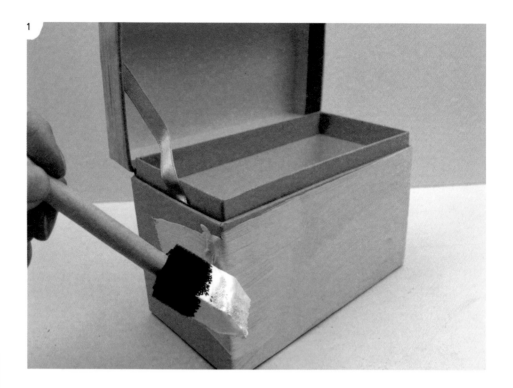

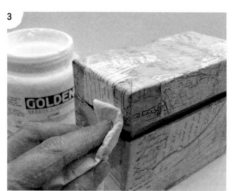

1. Start with a hinged papier-mâché box from a craft store. These are inexpensive, yet durable enough to hold up to a wet medium. To give the box extra rigidity, apply a coat of white gesso with a foam brush and allow it to dry thoroughly.

2. Tear up bits of paper ephemera to cover the outside of the box. Use a gel medium as an adhesive. It dries quickly, but has enough "open" time to allow you to smooth out any bubbles or wrinkles. Some bumpiness in the paper will occur, but that adds a nice texture to the finished project.

3. When the glued paper is dry, use a baby wipe to gently apply another thin coat of gesso. This step is optional, but I like it because it tones down the many colors and gives a nice surface to work on. Allow the gesso to dry thoroughly.

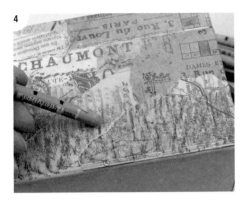

4. Now you're ready to color. Water-soluble crayons work best for this technique. I used Caran d'Ache Neocolor II crayons and began to scribble around the bottom of the box with the darkest shade. I colored two more shades of blue on the box, overlapping each layer and slowly moving up the box.

5. Using a soft, bristle oval brush dipped in water, paint over the crayon colors, which will instantly become fluid. Work your way around the box, blending water and the three shades of blue. This step should be done slowly and with very little water so that you are able to blend the crayon colors without washing them away.

6. Allow the first colors to dry well before you move on to a contrasting color. Cover the entire box in blended crayon and water to achieve a gradient look. If the pigment in the crayon is too vibrant, wipe it down with more water or a baby wipe.

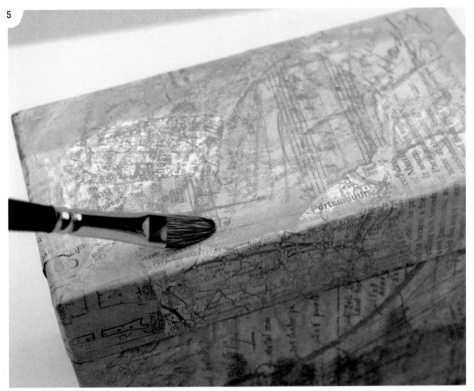

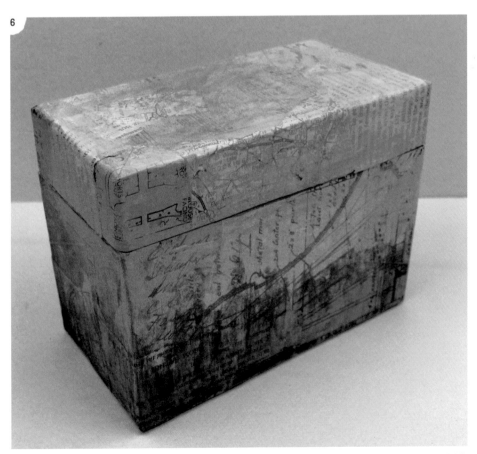

7

7. Once the crayon layer is dry, use a script stamp and white pigment ink pad to loosely stamp all over the crayon. The white ink is a perfect contrast to the color underneath. You can speed up the ink's drying time by using a heat gun to set it. I spritzed the entire box with a fixative to help prevent the bottom layers from moving and smearing.

8. Cut out strips of patterned scrapbook paper to create a border and bird motif for the box. Adhere those pieces with gel medium, being careful not to smear the water-soluble crayon underneath.

9. To make feet for the box, use little wooden knobs from a craft store and paint them with acrylic paint to match the colors of the box. Once dry, use craft glue to adhere them to the bottom of the box.

8

9

10. To add a bit of dimension and whimsy, dot the borders on the box with dimensional paint, being careful to let each side dry completely before moving to the next.

11. Use a dark gray crayon to outline the collaged images. Go over the marks lightly with a brush and water to blend them. This creates a drop shadow effect and makes the images appear as if they are sitting slightly off the surface.

12. Finish by spraying several coats of varnish on the box, allowing each layer to dry completely between coats. Once the box is varnished, there is no longer a danger of the crayon marks smearing. The varnish makes the box look almost woodlike—you would never know it was just a plain paper box when you started.

The finished project can be used for recipes, jewelry, or as a beautiful gift box. If you are interested in the technique, browse Chadbourne's website for more inspiration and consider taking one of her classes in which she so generously shares her love of dimensional art.

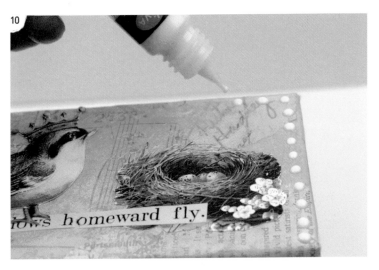

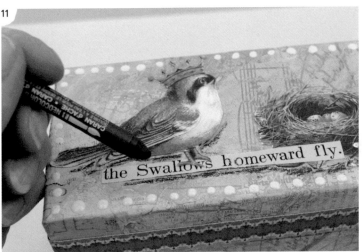

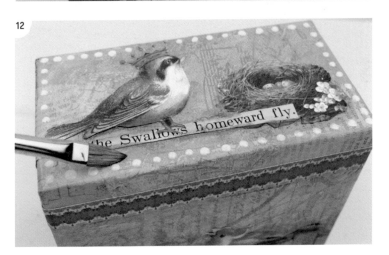

5
WAX RESIST

Tim Clary. Wax resist painting
by Yevgenia Watts.

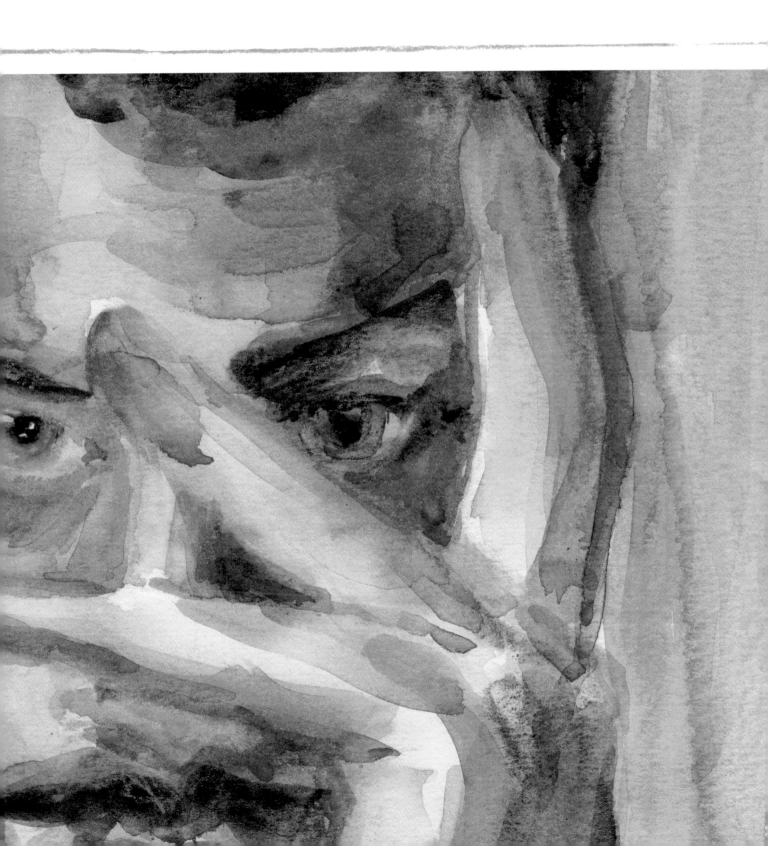

Introduction to Wax Resist

Bohemian Garden VI by Kathleen Pequignot. Crayon shapes determine the composition on a monoprinted background.

MELTING, POOLING, AND REPELLING

The amount of pigment packed into a crayon is what makes it a colorful medium for drawing. But artists have discovered that the other half of the crayon package—the wax binder that holds the pigment together—is also an interesting art medium.

The versatile wax crayon offers the ability to be melted or used as a resist, repelling water or watery mediums. If you draw with a crayon on paper, fabric, or wood, the waxy lines will act as a barrier to the substrate below. Paint on top of the lines and the wax will cause the liquid color to pool in puddles that push away from the wax, creating interesting patterns. Repeated in layers, the pooling can add a new dimension to a painted surface.

Many artists have discovered that, depending on the quality of the crayon, the pigment will leach out when wet medium is applied, adding to the mix of blended color. To keep the resist but avoid the color, some artists use clear wax crayons for this process. Alternatively, they might use the wax of a clear crayon to mask areas of a painting, protecting what's underneath from added color when paint is applied.

And then there are artists who take advantage of a crayon's waxy qualities, coming and going. As you will see on the next pages, Larry Walker has explored and exploited every quality crayons have to offer, using them to spectacular effect in his paper batiks. First, he uses the built-up quality of wax in crayons to create a solid surface of brilliant color. Then he uses the hard quality of wax to crackle the solid surface. Third, he uses the resistant quality of wax to paint over the colored surface with india ink, which settles into the crackle, but can be wiped from the surface. Finally, he removes the wax from the drawing altogether by heating the paper—leaving only transparent pigment behind. All that from a simple colored stick of wax!

LARRY WALKER
AND THE "TIFFANY GLASS" OF CRAYON

Ravenna Skies

STUDENT PROJECTS

When Larry Walker first went in search of a gallery to show his art, the word *crayon* did not help to open any doors. It didn't matter that Walker's pieces were detailed wonders bursting with color. Gallery owners equated crayon with children and that was that. Fortunately, there was one gallery, the Hazel Tree in Akron, Ohio, that actually looked at Walker's work.

Walker, who lives in Akron, graduated from Kent State University with a degree in graphic design. After twelve years working in advertising layout and illustration, he felt a strong pull toward fine art. He returned to Kent State and pursued yet another degree, this time in art education, followed a few years later by a master of fine arts. When Walker wasn't studying, he was teaching—sometimes both at the same time.

Each semester, Walker introduced his students to a crayon project. Crayon batik was one of them. As a painter who loved color, Walker became so interested in his students' batik projects that he decided to create some himself. He tried melted wax on canvas and other substrates, but he wasn't satisfied until he finally zeroed in on a technique that has gained him respect, recognition, and a thriving business creating art from crayon.

Flowers on a Checkered Table

Art Deco Daliah. Walker's images are bordered in art deco designs.

Art Nouveau Styling

"The realism of my work is putting what I see in my mind's eye into graphic images so others see what I do," Walker says. His love of architecture and line is evident in the way he designs his art deco borders and art nouveau styling. Walker researches all of his subjects and draws many thumbnail sketches before he begins the labor-intensive process of batiking.

"I know of no other artist using the crayon batik as a legitimate fine art medium," he says. It's based on the same principle as fabric batik: wax and water will not mix. Walker has adapted the process to paper, being careful to test the pigment to ensure light fastness and longevity. He uses bright white 60 lb (27 kg) paper as his substrate and starts by drawing his image in pencil. He goes over his lines again using waterproof permanent markers in varying weights, creating a black and white image that he will then color.

Walker uses Crayola crayons because of their transparency. With a full box of 120 crayons open in front of him, he fills in the entire drawing surface, laying the crayon down heavily and leaving no space uncovered.

Shore Lunch

The Steps Come Together

The next step is harrowing as Walker crumples the drawing that he has spent so many hours on into a ball, as if he were going to toss it in the trash. The crumpling produces cracks in the wax, some hairline and some much larger. Walker carefully smooths the drawing again and paints it with waterproof black india ink. The ink penetrates the cracks, leaving a spiderweb effect in the paper as he removes the ink from the surface with a damp sponge.

This "reveal" is the most exciting part for Walker as he starts to see his composition come together. In the final steps, he sandwiches the image between clean sheets of newsprint and applies heat with an iron to melt away the wax. When the wax is gone, only the stain of the color and the spiderweb lines remain. After 30 to 40 hours of work, he is rewarded with his image, fixed in the brilliant colors with the look of stained glass.

Peacock No. 1

The Orange Tree

Two Roosters

PROJECT:
Crayon Batik

MIXED MEDIA AND WAX RESIST

Larry Walker generously detailed his crayon-batik technique so that I could share it with you. Inspired by his incredible stained-glass effects, I decided to give the technique a try.

Each of Larry Walker's works takes 40 hours or more to produce. Patience is not one of my strong points, however, so for my first attempt, I started with a simple design. Even so, after I was about one-third of the way through, I could appreciate Walker's tenacity.

Creating the original drawing is as quick and easy as you want to make it. But when it comes to coloring in the design, it takes a long time to fill in every square inch (cm) of the paper with a heavy coating of crayon. To create a successful piece, you must cover the page completely with crayon, including the parts you'd like to remain white.

On the plus side, I found the coloring process curiously calming—thoughts of my childhood coloring books came to mind. And, of course, there's no need to rush. You don't have to complete the image in a single session. Start it, set it aside, and come back to it as often as needed until you're done.

You will discover as I did in the end that your finished piece is soft and supple, much like a piece of fabric. Stick with those hours of coloring and you'll create a beautiful piece of art ready to frame and hang prominently!

Tools and Materials

- bright white paper, 60 lb (27 kg) weight
- pencil, #2 or 4H
- kneaded eraser
- permanent black markers in different widths
- wax crayons
- super black waterproof india ink
- 1" (2.5 cm) soft bristle brush to spread the ink
- clean newsprint
- 3 natural sponges
- 3 basins of water
- paper towels
- iron

1. Lightly sketch your design in pencil on the white paper.

2. Trace over your pencil marks with permanent markers. Choose various widths of markers to add emphasis or detail to your design. Erase pencil lines.

3. Make sure your work surface is clean and smooth before you start coloring your design. Select your colors. Pressing the crayon heavily against the paper, begin coloring in your drawing. Fill every surface of the paper heavily with waxy color. White areas must be filled in with white crayon. The wax is needed as a resist against the india ink. Any areas that are not covered with wax will become black in the inking process.

4. When your coloring is complete, crumple the paper *lightly* as if you were going to throw it away. This will create hairline cracks in the wax surface. Don't crumple the paper too much or the ink will saturate it and you will lose your detail and color.

5. Carefully open the paper and smooth it flat. Lay the paper face up on several sheets of newsprint. Have your basins of water and sponges ready. Wet the sponges and squeeze out the excess water.

6. Working quickly, brush the india ink over your entire drawing.

3

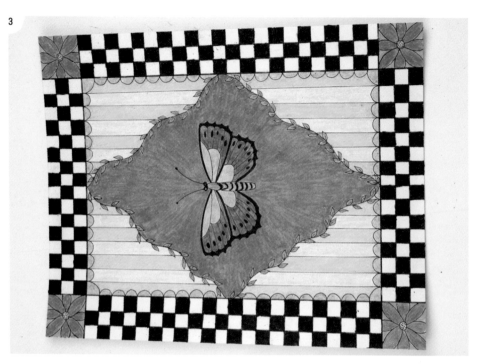

4

5

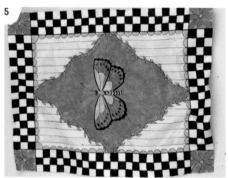

6

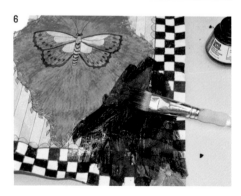

7. Before the ink dries, wipe it away from the crayon with the sponges. Keep the sponges damp but not saturated so you don't soak the paper and tear it. When you've wiped away all the ink from the colored areas, blot the drawing with paper towels.

Note
If your drawing is large, work step 7 in stages, inking and wiping one area at a time.

8. Carefully place the drawing on three or four sheets of clean newsprint, face up. Lay a single sheet of clean, dry newsprint on top of the drawing. Keep the top sheet of newsprint in place during the next step.

9. Heat the electric iron. Smooth the iron over the newsprint so that the heat penetrates to the drawing. Ironing will take the crumpled wrinkles out of the drawing paper. It will also melt the wax, which will be absorbed into the top layer of newsprint.

Replace the top sheet of newsprint with a clean sheet. Repeat step 9 two or three times until all of the wax is removed and the drawing is dry.

10. Flip the drawing over and iron the back of it to remove any leftover wax. Only the hairline india ink patterns and the "stain" or pigment from the crayons will remain in the softened drawing paper.

7

8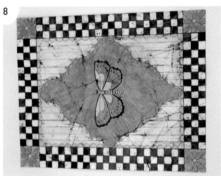

9

10

SHIRLEY ENDE-SAXE
MISCELLANY IN MOTION

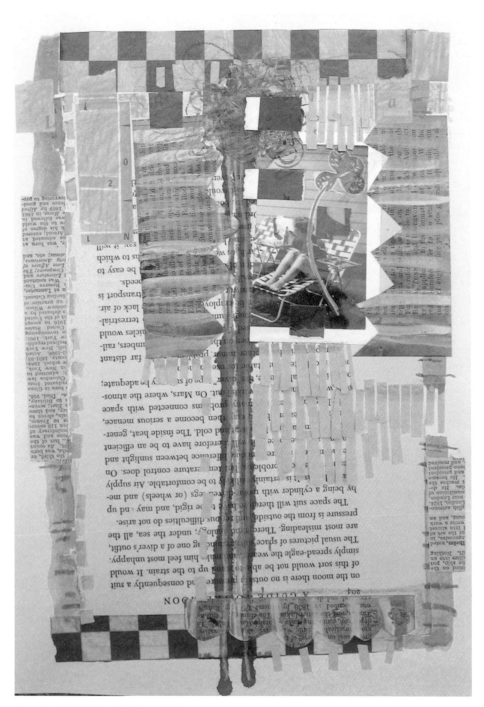

Green Luck for Madeline. Childlike scribbles and marks enhance the use of old text and photos.

TELLING A STORY

Shirley Ende-Saxe is a well-known mixed-media collage artist from Ohio who creates art about serious subjects, yet turns the art on its head with the materials she uses. In the 1980s and early '90s, Ende-Saxe came to be known as Rubber Grace, because of her focus on stamping and mail art. Ende-Saxe moved on to fiber art and eventually nestled into collage and art journaling.

Mandalas are a recurring theme in her work as her images float repetitively around the page. But it is her work in crayon resist that has caught the attention of crayon lovers everywhere. An art teacher in public schools and university settings for nearly thirty-six years, she is no stranger to the medium.

Ende-Saxe works intuitively yet tells a story as she works. She wants the viewer to think about the art she creates by using her materials in a narrative way with titles, words, and symbolism. She uses unconventional items such as vintage photographs, bits of ephemera, and plastic netting to help get her message across. She is an admirer of artist and author Chuck Close. His writings encouraged her "not to wait for the mood to strike. Just sit down and work and inspiration will come to you."

Ende-Saxe's crayon of choice is a soy-based crayon by Prang. She likes the textural smoothness and intensity of color they produce and confesses to owning some that are twenty or thirty years old.

A Blue Road to Black and White. Black-and-white vintage photos provide a stark contrast to blue paint and crayon lines.

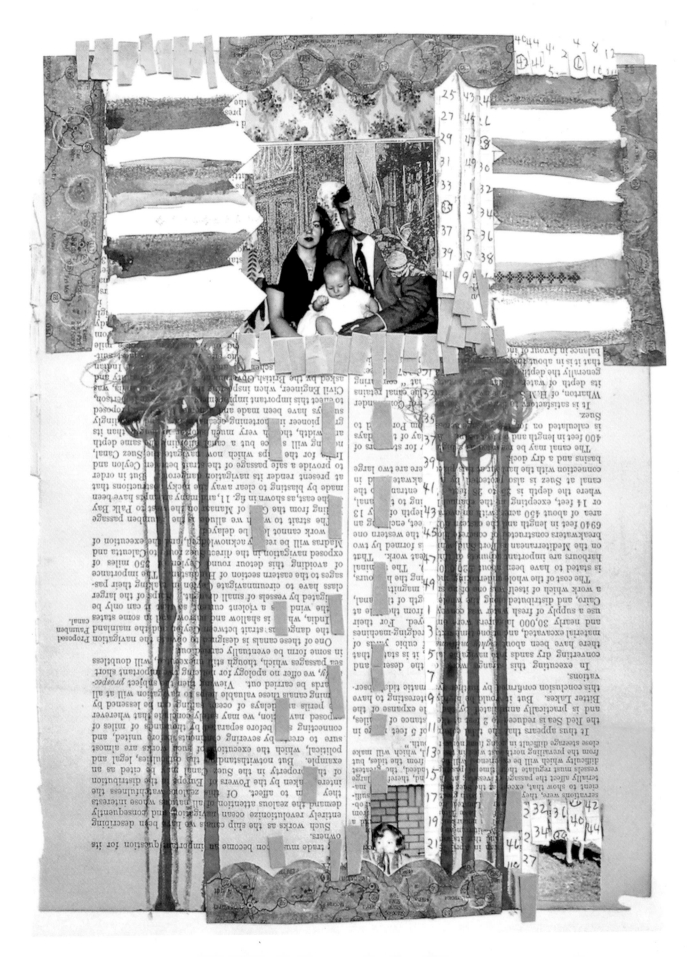

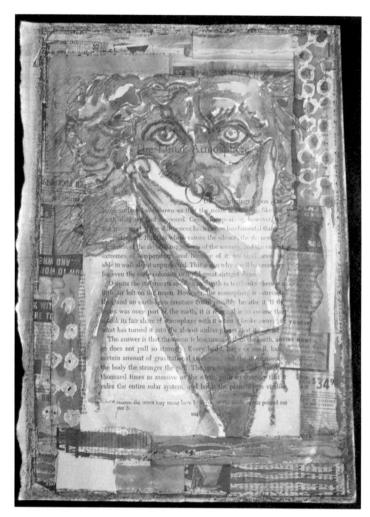

Self Portrait Pensive. Crayon drawing adds a playful quality to a serious self-portrait while the waxy lines provide dams to hold in pools of color.

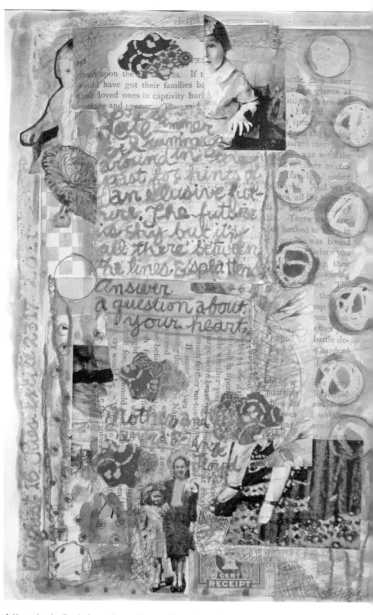

A Heart Looks Back. An art journal page shows how silver crayon marks add a resist and playful quality to the piece.

Bertha's Red Day. Paint over the top of scattered crayon marks creates intriguing backgrounds through resist.

Pearl Lotus Botany. In this example of one of Ende-Saxe's mandalas, crayoning is incorporated into the mix.

Pools of Color

"Crayons are quick and immediate," Ende-Saxe explains. When she feels her work is getting too tight and constrictive, she pulls out a crayon and adds a kinetic mark or scribble. This practice immediately gives movement to her pieces and allows her to push through.

Ende-Saxe also talks about movement when combining a crayon line with paint. Crayon lines on paper repel paint brushed over them. But crayon lines also hold the paint like a dam in little pools of color throughout her work. This process of resisting gives a sense of motion to her art.

"To me," Ende-Saxe says, "crayons represent an association to youth." She doesn't feel she has to be careful when working with crayons and this helps her process. "I'm using the crayon from the small person inside," she says. "It brings me delight."

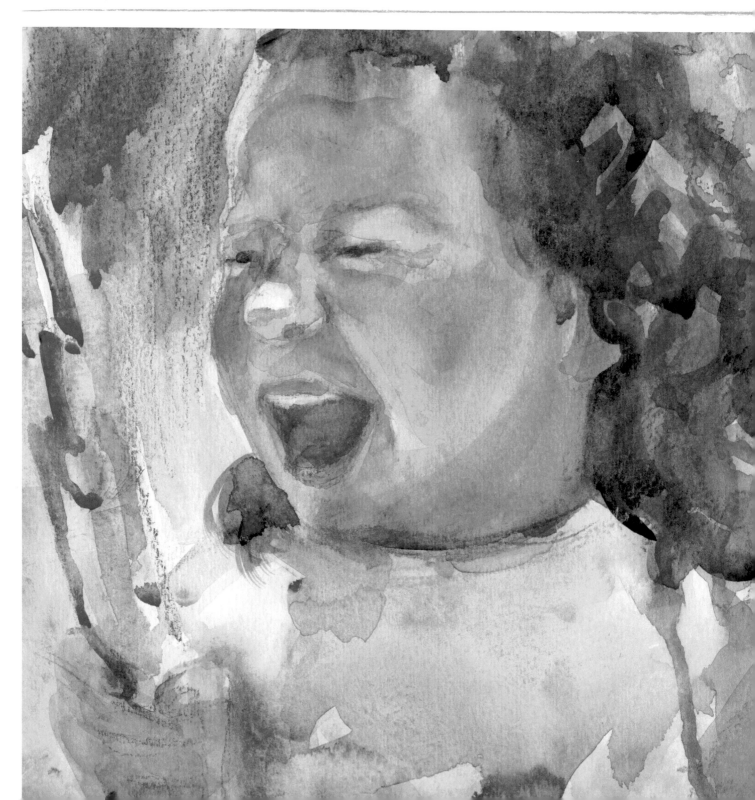

ART AS PART OF HER WORLD

"I discovered I was an artist as a child, somewhere between drawing on the wallpaper in my timeout corner and cutting out flowers from the curtains. That's what landed me there!" Yevgenia Watts recalls.

For as long as Watts can remember, art was a part of her world. With supportive parents who encouraged her creativity, at the age of nine she embarked on a steady course of art study in her homeland of Ukraine.

In 2003, when she was twenty one, her parents made the brave decision to flee their beloved country as religious refugees. The family landed in the United States to start their new life and Watts enrolled at the University of California, Berkeley, where she later earned her bachelor of arts degree in architecture. It wasn't until 2010, though, that Watts committed to a career as an artist.

Watts did not discover wax crayons until she moved to the United States. Having used only colored pencils as a child, she was at first disappointed that there wasn't enough pigment in crayons. They did not allow her to achieve the detail she was accustomed to with the sharpened point of a colored pencil. But having an inquisitive artistic mind, she set about searching for different ways to incorporate crayon into her work.

She admits that she is most drawn to the art-making process itself rather than the finished product. "I love to watch the paint move, to experiment and collaborate with the moody nature of watercolor. I adore watercolor, and I'm always excited to explore the endless color relationships."

Keira on a Swing.
Watercolor and crayon resist.

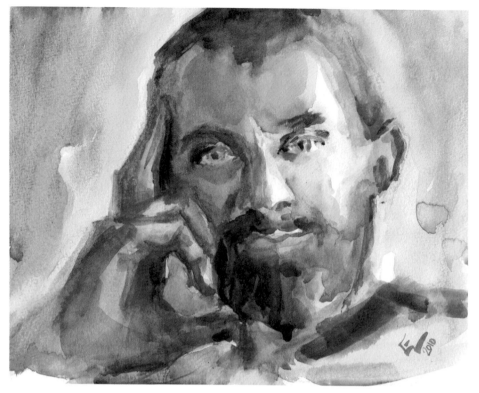

Giorgio Bordin

Like Painting on Glass

Watts, who now resides in Sacramento, is most known for her work in watercolor, specifically her magnificent flowing works on Yupo. Yupo is a synthetic substrate (polypropylene) with a slick, bright white surface. It is 100 percent recyclable and Earth friendly. This plastic-like paper was developed as an alternative surface on which to print labels and packaging. Yupo has now made its way into many artists' hands, and Watts describes the process as akin to painting on glass.

It was while using Yupo that Watts discovered the ability to draw on the substrate with light-colored crayons to create little reservoirs that held the watercolor in pools. The crayons also acted as a resist, creating interesting effects as the pigment was washed out of the crayon and blended with the paint. What remained were crisp, white lines and flowing color.

Quick, spontaneous pieces are Watts's favorites. As a mother of three small children, she has limited time but no shortage of crayons in her world. She likes to bend the rules with her art and find new ways to create interest.

"Crayons introduce an element of line and texture to my paintings and heighten the expressiveness of my work," she explains. Watt's architectural background gives her a good sense of perspective when sketching a piece and her use of bold, deliberate crayon lines contrast with the juicy, flowing colors.

Watts encourages others to create art with abandon and take joy in the process. And as for crayons? Watts says, "They're cheap. Get a lot of them and go play!"

Bell Peppers. Watery pools of color trapped in "gates" created with crayons used as a resist.

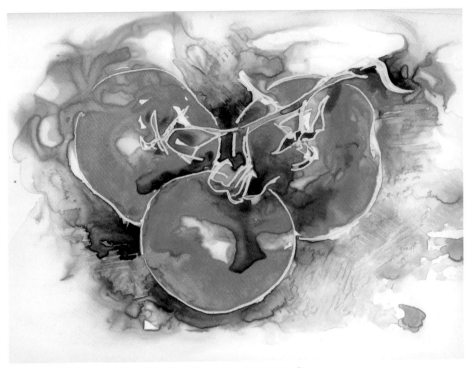

Tomato Juice. Broken crayon lines allow the juiciness of the tomatoes to flow.

Untitled. Watts shows expressive crayon lines in this abstract piece.

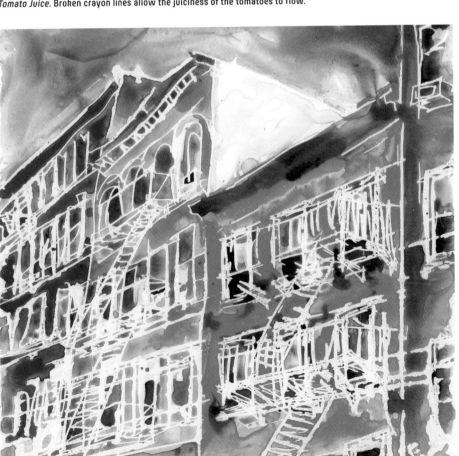

Bleeker Street. Watts's architectural crayon lines create structure for this piece that was done as part of a project entitled, *Virtual Paintout,* where artists choose locations to paint using Google Maps.

Improvised Monoprinting with Acrylic and Crayon

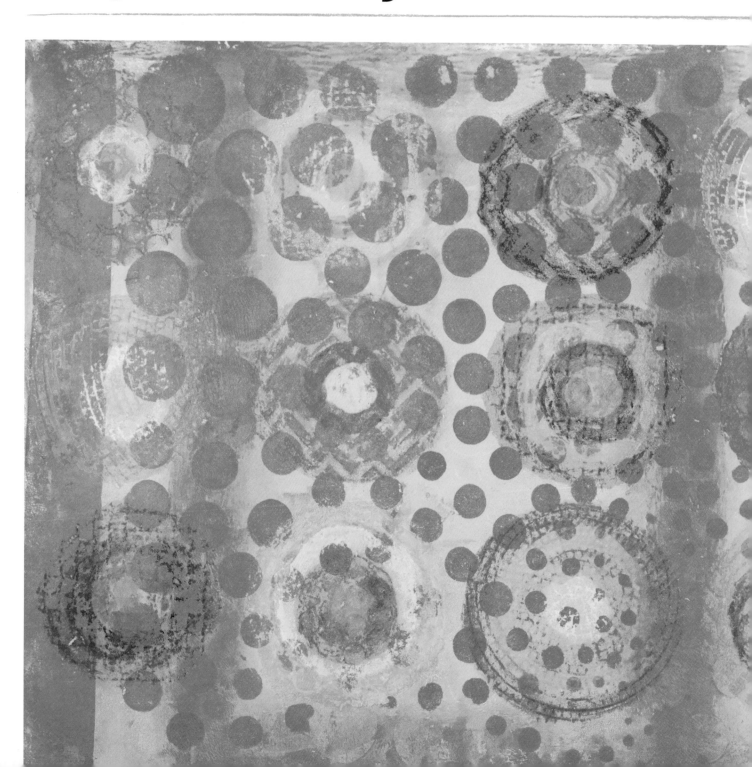

Combining crayon work with printing opens up a realm of possibilities for creating a new variety of designs that can stand on their own or be incorporated into mixed-media art works. One way to give the process a try without having to invest in a lot of printmaking equipment is through monoprints—original, one-of-a-kind art works created using a Gelli Arts printing plate. The gel plate is a spongy, gelatin-like substance that comes in a variety of sizes, does not require a printing press, and can be found in any art supply store.

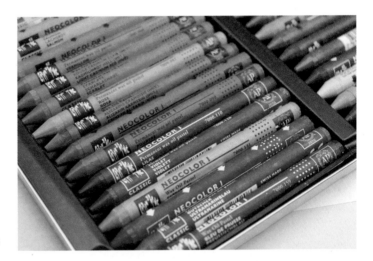

I used Caran d'Ache Neocolor I crayons for this project. I love the high pigment content and creamy quality of the wax, but what makes Neocolor I crayons perfect for this technique is that they are not water soluble. They combine with wet paint without smearing or bleeding.

I recommend using acrylic paint for Gelli printing—the choice of colors is endless and cleanup is easy. But if you prefer, you can also use water-soluble printing ink, or, if you're printing on textiles, use fabric paint. Test the printing process on any drawing paper (avoid glossy papers). A firm-bodied paper that will hold up to a little moisture works best.

This fun and colorful technique can turn out impressive results with whatever art and craft materials you have on hand. Play with it. Improvise with it. It will lead you in many directions and, once again, you'll be pleasantly surprised by the versatility of the wondrous little crayon.

Tools and Materials

- mark-making items, such as plastic canvas or punchinella
- Caran d'Ache Neocolor I crayons
- white drawing paper
- inexpensive acrylic craft paint
- Gelli Arts printing plate
- brayer
- baby wipes
- stencil
- palette knife

1. To add textural interest to my project, I grabbed some things I had around the studio. My choices included a piece of punchinella (waste from punching sequins), canvas backing for latch-hook rugs, and plastic canvas used for needlework. I often use these kinds of material for stencils or as debossing tools.

2. You can use the texture materials directly by placing them underneath a piece of drawing paper and coloring over them with a crayon. Or lay down some crayon color first, and then use the texture material on top, coloring over it with a second color.

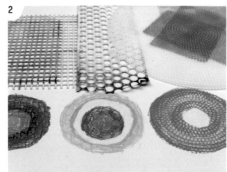

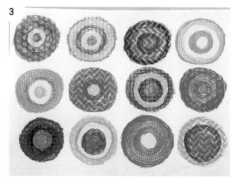

3. I used the mark-making tools and crayons to create Kandinsky-like circles on a piece of plain, white drawing paper.

4. It's always best to follow the directions that come with your Gelli Plate the first time you try it. Improvise as you like after that. I squirted acrylic paint directly onto the Gelli Plate and spread it with a brayer. When it was smooth, I rolled in stripes of a second color for interest.

5

6

7

5. To print, I lifted my colored-circle drawing, turned it over, lined it up with the Gelli Plate, and pressed it onto the wet paint, smoothing the paper with my hand. As I pulled the paper up, the paint covered the crayon marks, making interesting designs in the print.

The Gelli Plate is versatile; you can create many designs in a single print using a variety of stencils, colors, and mark-making tools. The plate has a wonderfully sensitive surface that will imprint any texture that you press into it.

6. I decided to add another layer of color to my print with the help of a multicircle stencil. After cleaning the plate with a baby wipe, I spread a fresh coat of paint onto the plate with a brayer.

7. Next I laid my stencil on top of the paint and *then* laid my print on top of the stencil, and smoothed it in place with my hand. When I lifted the paper, only the paint coming through the circles on the stencil was transferred onto my print.

8

8. Before it dried too much, I used a palette knife to gently scrape the paint from areas I'd colored with crayon. Scraping all the circles presented me with some nice surprises and interesting designs!

9. The finished design was bright and happy and the process was gratifying. I can see making stacks of these prints to use as one-of-a-kind papers in my mixed-media artwork.

9

Wheelsz. Black crayon marks create depth in this piece.

DISCOVERY IN THE PROCESS

Kathleen Pequignot has what she calls a "teacher's spirit" when it comes to sharing her art and technique. At home in central Florida, Pequignot has recently experienced a great shift from creating detailed watercolor and oil paintings, which she licensed to home décor companies, to the free-form world of mixed media and monoprinting. Take those two mediums, throw a little crayon into the mix, and you have a recipe for Pequignot's playful, happy works of art.

Pequignot discovered her love of crayon when she began to dabble in monoprinting. Using a Gelli Plate, Pequignot spent hours pulling prints that she created with layers of acrylic paint, stencils, and mark-making techniques.

She makes her prints on any paper she can get her hands on, but particularly loves the way they look on card stock. Discovery for her is the best part of the art process, and creating monoprints offers surprise and discovery with every piece.

Surrounded by stacks of her new work, Pequignot began searching through them for organic shapes, geometric patterns, and hidden stories. She leans toward linear work, and added crayon and charcoal drawing to the prints. For Pequignot, this was the point where her compositions came to life.

"This part of the process is rather Zen and therapeutic," she says. "I love the sketchy line achievable with crayons—like graffiti." She refers to this technique as "play" and prefers to use a child's crayon when she draws. "How serious can you be when you hold a crayon in your hand?" she asks.

Window Chimes. Vertical black crayon lines keep images from floating.

The Freedom to Let Go

Pequingnot prefers to work with traditional Crayola crayons because of their transparency and portability. She will often smear the crayon with charcoal to get a smoky effect that adds depth to the color. The result is far from childlike. She works her magic to coax images from the layers of paint created during the printing process.

Pequignot leans toward using darker crayons on her final layers. "When in doubt, grab the black," she says. The black line forces her to stay disciplined and not go overboard, only outlining feature items in her work. Yet at the same time, using crayon also helps her forget about perfectionism and allows her the freedom of letting go.

"Coloring is relaxing," Pequignot says. "There's something very basic, yet satisfying about a new box of crayons. Crayon can open the art imagination of adults who have forgotten how to enjoy color and line."

Other Worlds. White crayon adds a ghostly image to this piece.

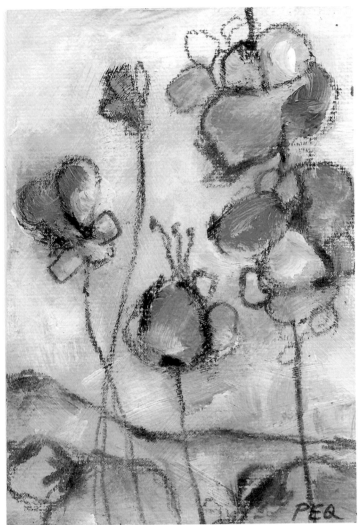

Spring Meadow I. Charcoal and crayon smeared together create a smoky effect.

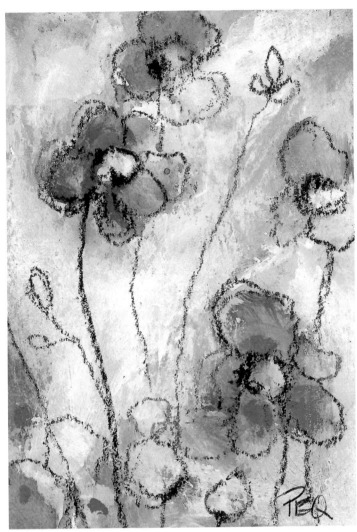

Bohemian Garden I. Black crayon marks pull out floral images from the acrylic printed background.

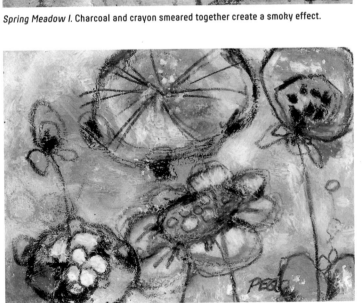

Bohemian Garden IV. Black crayon is a stark contrast to a complementary color palette of oranges and turquoises.

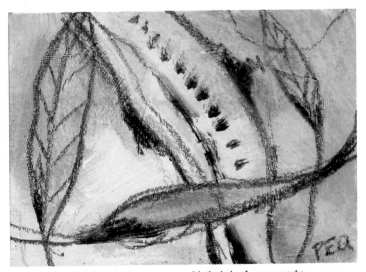

Bohemian Garden V. Organic shapes appear with the help of crayon marks.

Conclusion

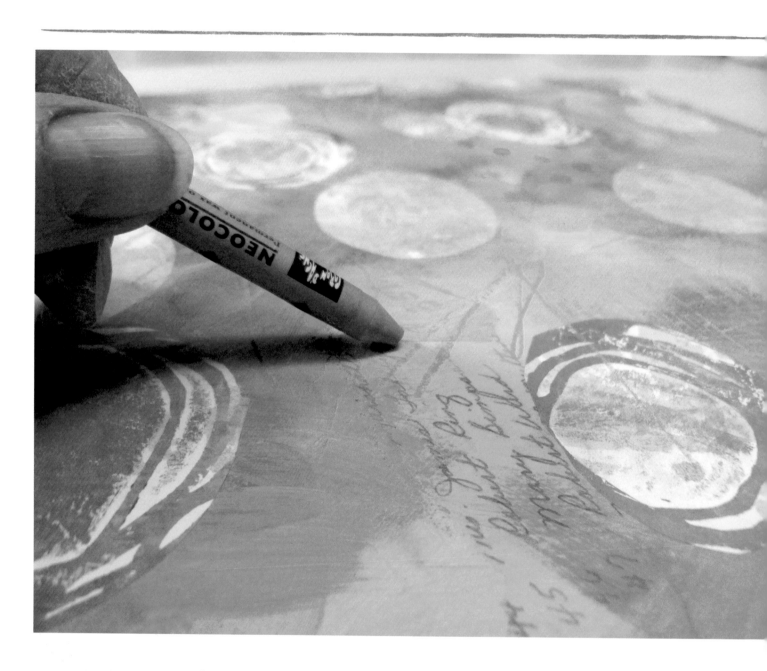

THE LITTLE WAX WONDER

The artists whose work appears on the pages of this book have described the simple wax crayon variously (and fondly) as nostalgic, stable, economical, emblematic, quick and immediate, basic, satisfying, iconic, transparent, portable, and symbolic of youth, vibrancy, and pop culture!

That's a lot of appreciation for a coloring stick most of us thought we left behind in grade school. And if we look for the descriptions these artists use for professional-grade crayons, the praiseworthy list of adjectives expands to include "intense, vibrant, creamy, and smooth." It seems there's something for everyone in each little wax package.

Crayons are among those basic, stable things, so common that most people never give them a thought—they're the Clark Kents of the art room that turn out to have superpowers.

In a drawing, crayon can appear from under a coat of paint or be applied on top of any surface, resisting water or working with it. Crayon color can rule on paper by itself—opaque or transparent, waxy or matte, as you wish.

As the artists in this book have shown, crayons are sturdy enough to be used like tiny building bricks to create monumental sculpture. They're solid enough to be drilled and carved to half their weight and still stand tall. Yet they're malleable enough that you can do the carving with a craft knife or scrape away the surface with your fingernail.

Crayons are hard enough, and their consistency smooth enough, that they can be sculpted to the exact miniature portraits of people, pets, or cartoon characters, yet they can also be melted and applied like paint to a surface, or molded and shaded to match any color under the sun.

Whether it's derived from petroleum, soy, or bees, wax has everything to do with the crayon's versatility. But wax was paired with pigment only as a means to deliver it to a piece of paper and to keep children's fingers clean, no matter how many sheets of paper they cover with color.

No one who developed the modern crayon had any idea what this generation of artists would create with them. It's the artists who have done the playful, exacting exploration of the crayon as object and colorant who have made the humble wax stick the most versatile, iconic, pop-culture art tool in the world.

Artists' Directory

Mary Jane Chadbourne
Las Vegas
desertdreamstudios.weebly.com

Diem Chau
Seattle
diemchau.com

Jane Davenport
Byron Bay, Australia
janedavenport.com

Jane Davies
Rupert, Vermont
janedaviesstudios.com

Shirley Ende-Saxe
Cuyahoga Falls, Ohio
shirleyendesaxe.typepad.com

Christian Faur
Granville, Ohio
christianfaur.com

Jacqueline Fehl
Ashville, North Carolina
jacquifehl.com

Pete Goldlust
Bisbee, Arizona
petegoldlust.com

Fred Hatt
Brooklyn, New York
fredhatt.com

Lynne Hoppe
Adin, California
lynnehoppe.blogspot.com

Aletha Kuschan
District Heights, Maryland
alethakuschan.wordpress.com

John Lovett
Queensland, Australia
johnlovett.com

Elena Nosyreva
Dallas
elena-nosyreva.artistwebsites.com

Kathleen Pequignot
Longwood, Florida
kpequignot.wordpress.com

Hoang Tran
Sunnyvale, California
facebook.com/carvedcrayons

Emmie van Biervliet
Oxford, UK
emmievb.com

Larry Walker
Mogadore, Ohio
paintings-sculpture.com

Yevgenia Watts
Sacramento, California
yevgeniawatts.com

Ed Welter
Portland, Oregon
crayoncollecting.com

Herb Williams
Nashville, Tennessee
herbwilliamsart.com

An example of
Jane Davenport's
ephemeral faces

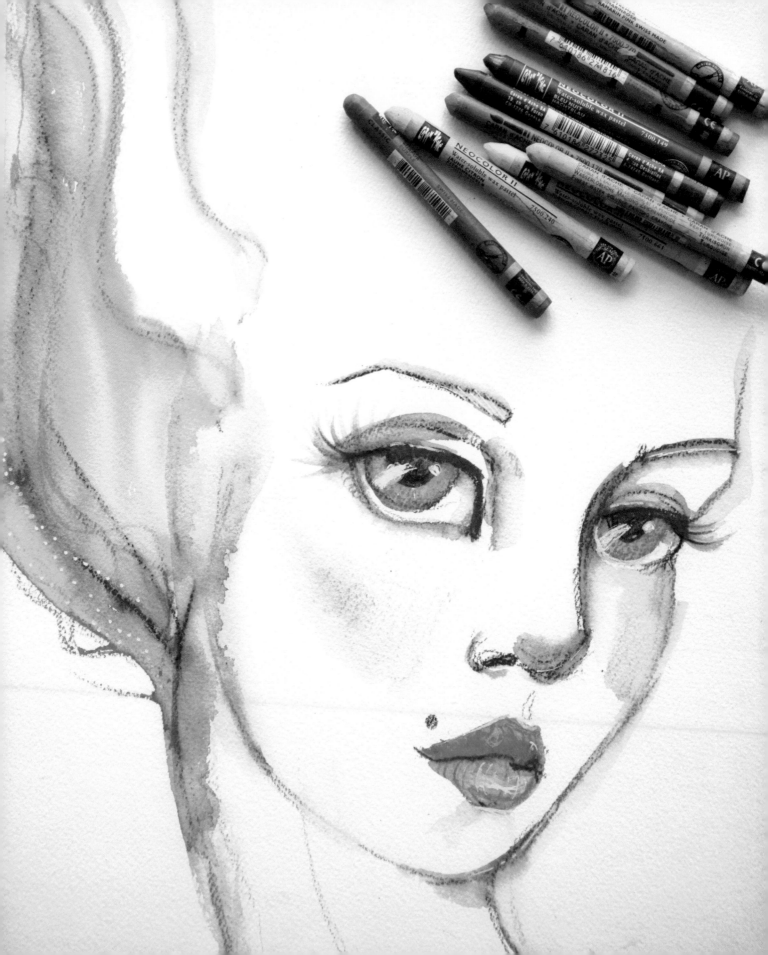

Resources and Supplies

For art supplies, I recommend the following online sites, where I buy most of the supplies I use in my studio: Dick Blick and Jerry's Artarama for paint, paper, brushes, tools, cradled boards, heat guns, and carving tools.
www.dickblick.com
www.jerrysartarama.com

Crayons can be purchased directly from the manufacturers such as Crayola, Caran d'Ache, Faber Castell, and many others.
http://shop.crayola.com/art-and-craft-supplies/crayons
http://store.carandache.com/us-en
www.fabercastell.com

For stencils, I love the selections offered by The Stencil Girl and The Crafter's Workshop.
www.stencilgirlproducts.com
thecraftersworkshop.com

Monoprinting plates can be purchased directly from Gelli Arts.
www.gelliarts.com

For ephemera, I comb thrift and antique stores for old postage stamps, letters, ledgers, and books, and I'm not above begging for junk that people throw away!

TO LEARN MORE

Websites on crayon art and information
www.crayoncollecting.com
http://crayoncollecting.blogspot.com
www.crayoncollection.org

Galleries that have featured crayon art
www.therymergallery.com
http://kimfostergallery.com
www.sherriegallerie.com

Crayon Facts and Trivia

- Crayons have been made by more than 300 different companies over the past century. http://allday.com/post/1102-13-fascinating-facts-about-crayons/

- To date, more than 100 billion crayons have been produced in the world. http://didyouknow.org/crayons/

- The word *crayon* can be traced back to 1644, derived from the French word *craie* (chalk) and the Latin word *creta* (Earth). www.crayoncollecting.com/hoc01.htm

- By the time you are 10 years old, you will have used up approximately 720 crayons. http://allday.com/post/1102-13-fascinating-facts-about-crayons/

- The first literary use of crayons is in Jane Austen's 1813 novel, *Pride and Prejudice*. "Elizabeth Bennet looks at some of Mr. Darcy's sister's crayon art work." http://allday.com/post/1102-13-fascinating-facts-about-crayons/

- The original Crayola company (Binney & Smith) used whale blubber in its crayon recipe. This ingredient has since been removed. http://allday.com/post/1102-13-fascinating-facts-about-crayons/

- A Yale University study determined that the scent of Crayola crayons is one of the top twenty most recognizable scents in existence. Topping that list are coffee and peanut butter. http://allday.com/post/1102-13-fascinating-facts-about-crayons/

- Most kids spend an average of half an hour per day coloring. www.ideafinder.com/history/inventions/crayon.htm

- Binney & Smith produces nearly 3 billion crayons each year, an average of 12 million wax sticks daily—enough to circle the globe six times. www.deseretnews.com/article/985312/Colorful-trivia-about-Crayons--blue-is-favorite-hue.html?pg-all

- More than 100 million crayons are thrown out every year by more than 15,000 family-style restaurant chains across the United States. www.crayoncollection.org/Crayon-Factoids.doc

- Crayon waste has a significant, negative environmental impact. Made from paraffin wax, which is derived from petroleum, it can take years (even decades) for a crayon to decompose in a landfill. www.crayoncollection.org/Crayon-Factoids.doc

- Thank goodness there is a National Crayon Recycling Program. http://crazycrayons.com/recycle_program.html

- Grant Wood, creator of one of America's most recognized paintings, *American Gothic*, once entered and won a prize in a Crayola coloring contest. He was fourteen years old. http://articles.baltimoresun.com/1996-09-22/features/1996266193_1_crayons-binney-easton

- Sixteenth-century French artists such as François Clouet and Nicholas L'agneau used wax crayons in their art. www.historyofpencils.com/writing-instruments-history/history-of-crayons/

- Louis Prang, who is one of the fathers of art education in the United States, manufactured watercolor crayons and sold them from the late nineteenth to the early twentieth century. www.historyofpencils.com/writing-instruments-history/history-of-crayons/

- Crayola produced its sixty-four–pack of crayons in 1958. It made its debut on the television show, *Captain Kangaroo*. https://tbrockhaus.wordpress.com/category/random-facts/

Acknowledgments

Much gratitude and great love goes to my husband, Michael, who suddenly passed away before he saw this book completed. I am thankful for his patience during the hours and nights and weekends that I worked to make deadlines and for his encouragement and help in chasing my dreams. Thanks to my daughter, Chelsea, and son, Christian, who are my biggest cheerleaders. I secretly loved the fact that they bragged about Mom being an author every chance they got! I love you all.

I would like to thank each and every artist I met during this project for their enthusiasm and generosity in sharing their creative process. I also want to thank them for their patience as I relentlessly hunted them down for an interview! Most of all, I am grateful for the interesting conversations, friendships formed, and invitations to visit their galleries and studios around the world. I hope to one day make those journeys! They were all incredibly fun and interesting and opened my eyes to a world of possibilities!

Special thanks to Rockport Publishers and to my editor, Judith Cressy, who held my hand as a first-time author and cracked the whip when she needed to, while at the same time making me believe that I could do it.

And to Mom and Dad who urged me to keep working to get this book finished, even when I thought I couldn't take one more step.

About the Author

LORRAINE BELL
ARTIST•WANDERER•DREAMER

Mixed-media artist Lorraine Bell splits her time between Windermere, Florida, and the Cayman Islands. A painter, sketcher, traveler, and writer, she combines these talents to create illustrated art journals that are bursting with images and inspirations from her adventures on the road.

Lorraine has been involved with the art industry for more than twenty-five years. She owned and operated an art supply store in the Cayman Islands for ten years, hosting events that focused on the talents of local artists. She is now the owner of Serendipity Studios and is one of the founding artists who make up the collaborative team of Art to the 5th. She created a visual calendar/journal that is the inspiration for The Documented Life Project, a yearlong undertaking that encourages the concept of visual and written chronicles of daily life. Lorraine teaches online tutorials on her Serendipity Studios website and Brave Girl University. She also teaches on-site workshops and maintains her own mixed-media and paper art shop on Etsy. She is constantly studying art and looking for new ways to expand her creative abilities. You can find Lorraine at LorraineBell.com.

Photo credit:
Christian Bell

Index